Visions of Courtly India

Visions of Courtly India

The Archer Collection of Pahari Miniatures

Introduction and Catalogue by

W. G. ARCHER

CIRCULATED BY

International Exhibitions Foundation

Washington, D.C.

1976 – 1978

© International Exhibitions Foundation, 1976
Library of Congress Catalogue Card Number 76–18030
ISBN: 0 85667 032 4

This project is supported by grants from the National Endowment for the
Arts, Washington, D.C., a Federal Agency, and from the JDR 3rd Fund.

Cover: Parvati Alone, Garhwal School, c. 1785. Catalogue no. 14.

Contents

PARTICIPATING MUSEUMS

UNIVERSITY ART MUSEUM
Austin, Texas

ST. LOUIS ART MUSEUM
St. Louis, Missouri

DENVER ART MUSEUM
Denver, Colorado

DES MOINES ART CENTER
Des Moines, Iowa

LOS ANGELES COUNTY MUSEUM
Los Angeles, California

NELSON GALLERY OF ART
Kansas City, Missouri

SEATTLE ART MUSEUM
Seattle, Washington

INSTITUTE FOR THE ARTS
Houston, Texas

FINE ARTS MUSEUM OF THE SOUTH
Mobile, Alabama

LAKEVIEW CENTER FOR THE ARTS AND SCIENCES
Peoria, Illinois

Acknowledgments

IT is with great pleasure that the International Exhibitions Foundation presents this splendid collection of eighty Pahari miniature paintings from fourteen Indian schools, assembled over many years by W. G. and Mildred Archer. I am grateful to them and to their children, Michael Archer and Mrs. Margaret Lecomber, the present owners of the collection, for making these works available to us for an extended tour of museums and galleries throughout the United States.

In addition to being collectors, Dr. and Mrs. Archer are recognized scholars; he is Keeper Emeritus of the Indian Section of the Victoria and Albert Museum, and she has long been associated with the India Office Library. Working together and individually, they have published extensively in this fascinating area of Indian art. In particular, I wish to acknowledge Dr. Archer's contribution in providing the scholarly introduction and the individual entries for this catalogue which will be an important addition to the literature on the subject.

I would like to express my profound gratitude to the National Endowment for the Arts, a Federal Agency, and the JDR 3rd Fund for their generous grants which helped substantially in the preparation of the exhibition and the catalogue respectively.

We appreciate Mrs. Margaret Breitenbach's assistance in editing the text, and wish to thank William J. Glick of The Meriden Gravure Company for his skill in bringing the catalogue to completion.

We also wish to thank Philip Wilson and Sotheby Parke Bernet Publications for their help with many details involved in this project.

Three members of the staff, Stephanie Belt, Heidi von Kann and Margy P. Sharpe, have been most helpful as always in every phase of the organization of the exhibition and its catalogue.

ANNEMARIE H. POPE
President
International Exhibitions Foundation

Introduction

To a young member of the Indian Civil Service, still fresh to India after ten years in that country, Patna in 1941 was hardly a congenial posting. It might differ, in certain respects, from the Chandrapore of *A Passage to India* but it was difficult to erase Forster's famous description:

> Edged rather than washed by the river Ganges, it trails for a couple of miles along the bank, scarcely distinguishable from the rubbish it deposits so freely.... There is no painting and scarcely any carving in the bazaars. The very wood seems made of mud, the inhabitants of mud moving.... As for the civil station itself, it provokes no emotion. It charms not, neither does it repel. It is sensibly planned. It has nothing hideous in it and only the view is beautiful; it shares nothing with the city, except the over-arching sky.

I had come from a part of India where the tribal peoples danced and sang, but, arriving in Patna, it was as if exhilaration abruptly stopped. One was in a land not of poetry and romance but prose and mud.

One evening in November, the air calm and clear after the monsoon rains, I chanced to call on Mr. P. C. Manuk and his beloved companion, Miss G. M. Coles. They were well known in Bihar for their large collection of Indian miniatures. Acquaintances had sometimes expressed surprise that I had never gone to see them. "You like pictures," they would say, "and you haven't seen old Manuk's?" But I was young, resolute and opinionated. Excited by Cézanne, Picasso and Negro art, by the modern and the primitive as against the classical and refined, I tended to scoff at what was exquisite or figurative. I preferred instead the nineteenth-century drawings of Kalighat, boldly simplified, with great bounding curves, as in pictures by Léger; or the primitive sculptures of tiger-haunted jungles about which I was later to write my book *The Vertical Man*. To miniatures, I believed I was firmly allergic. Yet a District Magistrate, for that is what I was, must know his neighbors. "P.C.," as Manuk was called, was the greatest lawyer in Eastern India. I could hardly ignore him; so, overcoming my reluctance, I went and called.

The experience that evening was a turning-point in my life. As "P.C." brought out his pictures, hinged on great sheets of card in albums with scarlet leather covers, I marveled at what I saw and gasped at the stupid arrogance that had prevented me from going to see him previously. The pictures, which were miniatures dating

from the sixteenth to early nineteenth centuries, bore no relation to modern India. They were as remote from the village India that thrilled and delighted me as Books of Hours or miniatures by Hilliard were removed from twentieth-century England. They were products of feudal India, an India which dimly lingered in some of the princely states but which for the rest had long ago succumbed to the industrial revolution, railways, motor-cars, cameras and the British. Many were Mughal. Others were Pahari (from the Hindi word *pahar*, meaning "hill"), and it was these—from the Punjab Hills in northern India—that caught my eye. It was as if I had stumbled on a collection of Elizabethan lyrics and was discovering for the first time the mainstream of English love-poetry. The language might not be modern—it was hardly the idiom of a W. H. Auden or a Robert Lowell—but it expressed with matchless elegance the tender nuances of romantic passion.

Manuk's Pahari pictures were the exact equivalents in Indian painting of this English love-poetry. In the states of Kangra and Garhwal—two regions in the Punjab Hills—the painters employed a flowing, rhythmical line to convey the nobility of love. They celebrated Krishna, the divine lover, and his cowgirl mistress, Radha, as embodiments of physical grace. They showed men and women in various states of love and portrayed with quiet tact the supreme moment of romance, "the meeting of eyes." Yet their treatment—and it was this that fascinated and intrigued me—was essentially poetic. Color was used to hint at poetic associations. The scarlet of a girl's skirt was echoed in the red of a gathering storm. Imagery was included not for baldly descriptive purposes but to provide symbolic settings. I knew how vital a role such images played in Indian tribal poetry, where leopards and tigers were often used as conventional symbols for the lover. But here the same poetic approach was translated into painting. A lady, fretting in her chamber as she recalled her absent lover, was portrayed against a sky tormented with storm. The onset of passion was revealed by rolling clouds and stabs of lightning. Birds in pairs were often introduced as emblems of married love; and even trees, their broad trunks entwined by loving creepers, were vivid parallels of embracing lovers.

Such pictures, seen in the quiet of P. C. Manuk's study in Patna, changed my whole approach to Indian painting. I now saw it as a type of art to which even a hardened adherent of the modern movement could respond. I recalled the enigma of Giorgione's *La Tempesta* where the mounting storm matched, in the same poetic way, the tension between the waiting soldier and the brooding woman. And, had I known of him then, I might well have called to mind Paul Delvaux, the Belgian surrealist painter, equally preoccupied with passionate encounters and poetic symbols. A new world had opened and guided by Manuk himself in my first fumbling efforts, I began to collect and, through collecting, to embark on my life's main study—the appreciation and history of Indian painting.

The present collection of eighty Pahari miniatures derives from the kind of picture that had so stunned me when I saw it for the first time with Manuk. I did not consciously begin to seek out Pahari miniatures, but it happened that the leading dealer of the time, Radha Krishna Bharany, specialized in them. He lived at Amritsar and was buying up pictures from the Punjab Hills. By 1941 the supply of Mughal paintings had almost ceased

but descendants of the former ruling families in the Punjab Hill States (present-day Jammu and Himachal Pradesh) were disposing of their ancestral pictures. Radha Krishna Bharany regularly came to Patna to see Manuk and it was from him that my wife and I made our first purchases. Although we ourselves had only purchased some thirty Pahari pictures by the time we left India in 1948, we had seen and handled vast numbers. Bharany would arrive at our bungalow, open a tin trunk and spread miniature after miniature out on the floor. Many were indeed romantic and poetic, but as we went through the hundreds of pictures which he showed us, a new realization dawned upon us. Far from all Pahari miniatures being sensitive, delicate and refined, numbers had the same qualities of formal distortion and bold simplification that I admired in modern and primitive art. Indeed, in this respect, the courtly art of the Punjab Hills was often little different from Indian village art. The revelation of their poetic character had rid me of my former allergy to miniatures; but it had supplemented, not destroyed, my passion for other, less representational types of art. Confronted by Pahari pictures in the mass, I bought some which were truly romantic but I also bought others which were the very reverse. In these there were often strange dislocations of size and physique. At times the figures were squat, at others tall. The palettes were startling—the hot and dramatic competing with the cool and pallid. Backgrounds were sometimes flat and symbolic and at others, deftly naturalistic. Faces and physiques varied from the calm, the tender and the lovely to the angular, the wild and the brutal. Even subjects were far more varied than I had supposed. The encounters of ideal lovers—ideal because they were imaginary rather than real, feudal fantasies rather than life as it was—had certainly aroused courtly interest. So too had the loves of Krishna. But these were wish-fulfillments, expressions of the Rajput need for extramarital love, for love as a romantic passion rather than for love as it was normally experienced within the strict framework of arranged marriages. Only with courtesans and dancing-girls, in fact, could passion of the kind mirrored in the pictures be explored or simulated. But besides the passionate and sensuous, there were other types of subject. The normal round of courtly life with its interest in durbars, music, hunting, dancing and family occasions bulked equally large; and life as it really was came steadily closer. Then, too, there was religion. The ferocious activities of the Devi, hungry for blood, and the stern actions of Shiva, at once erotic and ascetic, were portrayed. The adventures of Rama (seventh incarnation of Vishnu), his quest for Sita, abducted by the demon king, Ravana, and the career of Krishna, no longer romantic lover but feudal princeling—these also were treated. To each of these subjects, Pahari artists applied their various contrasting styles, at times delicate, at others tough. It was from this miscellaneous assortment of pictures, all of them Pahari but all in various ways distinctive, that I obtained my first collector's thrill.

To collect in India in the years before Independence was one thing; to continue collecting once I had left was another. Why did I continue? A first reason, I suppose, was frankly hedonistic. I enjoyed Pahari miniatures —whatever their styles—and I liked having them around me. They seemed extensions of myself, evidence of my tastes, enthusiasms and beliefs. They reminded me of the country I had left and of my passion for India and its people. To look at them was to recall past excitements. Moreover, like all works of art, they had "lives of their

own." One never knew quite what one would see when one next looked at them. Walking into a room, looking at them on a wall, taking them out of their boxes, pondering on them as I relaxed at home, I found that their subtleties and nuances of style would penetrate my sensibility anew. I would notice fresh details, characteristic mannerisms or essential traits; and, as I looked I would get the feeling of elation that comes from totally unexpected encounters. To increase the number of such life-enhancing occasions, to add to the collection as and when opportunity and money allowed, was to inject one's urban routine with new vitality, the thrill of the chase, the tonic of constant surprises.

My second reason was professional. In 1949, I had joined the Victoria and Albert Museum, London, as Keeper of the Indian Section and one of my principal duties was to catalogue its collection of pictures. It had recently been given part of Manuk's own Pahari collection, and I threw myself with zest into the task of distinguishing schools and styles, identifying themes and subjects, and determining dates. Little enough was known, but my experience of Indian dealers and their enormous stocks of pictures had given me an eye for style. I had also had access to their subterranean "knowledge"—"knowledge" such as what was "Kangra," what was "Garhwal," what was "Basohli." This "knowledge" was rarely supported by firm facts but it was the chief framework that existed and it was one that was always used when scholars and connoisseurs discussed Pahari pictures. Onto this I had grafted the various impressions I had gleaned in the course of moving round the northern half of India before I left it in 1948. I had seen and photographed public and private collections and had discussed them with experienced collectors such as Karl Khandalavala, Rai Krishnadasa, Samarendra Nath Gupta and Gopi Krishna Kanoria. As a result, I found myself with a fund of raw ideas, tentative theories, intuitions, hunches and perhaps, above all, with an acute awareness of how complex and still unexplored were the great majority of Pahari styles. The Museum itself possessed a small cross-section and during the ten years during which, as Keeper, I could determine policy, some great Pahari collections were added—the Rothenstein, Gayer-Anderson, Lory and part of the J. C. French—as well as a multitude of separate purchases. But the Museum's resources were limited. Many pictures were either "too expensive" or, oddly enough, "too cheap." It was sometimes assumed that because they were "cheap" they must therefore be "worthless." Even the large number of official acquisitions I had made were at times the subject of friendly criticism by colleagues in other Departments. "Haven't you got just about enough of your beastly miniatures, Bill?" they would say. The climate gradually changed, and by the time I ceased to be Keeper in 1959, the Indian Section had become "satiated" with Pahari paintings and needed other things. Yet the research to which, as Keeper Emeritus, I was now committed demanded the filling of gaps, the preservation of new evidence and, especially, the acquisition of examples which defied immediate recognition. When, therefore, pictures of this sort came on the London market and my wife and I had enough money of our own to buy them, the starved collectors in us rose to the surface. We bought them because my other self, the art historian, could not bear to see them vanish.

The upshot is reflected in my book *Indian Paintings from the Punjab Hills*, to which the present exhibition

xii

may perhaps provide a slight but scholarly sequel. In attempting so full a survey and history of the subject, I had rarely been able to put it wholly out of my mind. Its problems obsessed me whether I was at the Museum, at home or on holiday. They took me back to India four times before I at last reached my ultimate conclusions. In India, I was escorted by my friend M. S. Randhawa to many of the States in which the miniatures had been produced. I could experience the violent changes of scenery and climate which often threw light on differences of style. The cultures which underlay the pictures became more vivid. Yet, in the end, it was our miniatures that imposed their wills, revealed their identities and determined my reconstructions. Agonizing over which pictures belonged to which schools, I would turn to those that were most readily to hand. Without a true Basohli picture of our own, I doubt if I would ever have sensed how firmly disciplined was its composition and, despite its fierce distortions, how strict was its organization. Without our Kulu pictures, I might never have realized how tense and frantic were their moods and with what contrasting types of rhythm they distinguished themselves from those of Basohli. If we had not owned a particular portrait of a ruler with a falcon—a portrait which at one time I had thought was "Chamba"—I might not have paid attention to another version of it in the National Museum, New Delhi. This was inscribed with the name of the ruler, Suraj Mal of Nurpur, and in the light of what I had since come to know about Nurpur painting, "Nurpur," not "Chamba," it had to be. Above all, as I was looking at another of our "Kulu" pictures—a lady at her toilet surrounded by maids—the wriggly lines between the stripes of a rug struck me as "wrong" for "Kulu." These lines occurred only in Mandi pictures and pondering their implications, I looked again. Alas! there were more and more details that could only be "Mandi" and, as I saw them, "Kulu" melted quietly away. Such experiences are vital to an art historian, and whatever I may have accomplished in that capacity is due in great part to the fact that my wife and I have had a private collection, of which perhaps the most significant examples are in this exhibition.

W. G. ARCHER

Catalogue and Plates

BAGHAL (ARKI)

1. *A Prince Confers*

$6^{1}/_{4} \times 8^{1}/_{2}$ in.
Inscribed on reverse in *takri* characters: *rana
 chandol bagat chand*

Baghal, a small state in the stony Sewalik Hills, adjoins the Punjab Plains and is bounded on the southwest by Hindur, on the northwest by Kahlur (Bilaspur) and on the north by Suket. Its capital, Arki, is twenty-one miles from Simla. Little is known of its history but the royal family attached great importance to the purity of its blood and is said to have married chiefly in Kahlur.

Like the Bilaspur family, the rulers of Baghal employed the suffix "Chand" but preferred the royal title of "Rana" to the more customary title, "Raja." "Rana" was the title affected by the rulers of Mewar, premier state of Rajasthan and the word "Chandol," appearing in the inscription, may imply that as in Bilaspur— where branches of the royal family were often known as "Chandel" or "Chandla" Rajputs—the Baghal family was, in some way, connected with the same Rajput area of Chanderi (Bundelkhand) from which the word "Chandol" derives.

In this picture, a young Baghal prince, his checkered turban similar to those worn by Rana Mehr Chand (1727–1741) of Baghal in other portraits,[1] is offered the hookah by a standing attendant whose short dress evidences a date of about 1700. The white fly-whisk fluttering over him, the sword lying by his side and the courteous pose of the seated courtier—perhaps his younger brother —offering him betel-leaf emphasize his royal stature. The bunch of daisies which he holds hints, however, at other interests—the pleasures of the zenana—and the floral-patterned rug introduces a slight note of foppish degeneracy. Although no ruler named Baghat Chand is recorded from Baghal, the prince's features closely resemble those of gallants with their ladies in other Baghal paintings. If, as is possible, Baghat Chand was heir-apparent to Rana Prithi Chand (1670–1727) of Baghal and predeceased him, this might explain his depiction with royal emblems. The sage green background and upper band of white and blue are standard Kahlur conventions, but the hesitant, meandering line connecting the four personages is typical of Baghal.

1. Archer, *Indian Paintings from the Punjab Hills* (1973), Baghal nos. 8, 12.

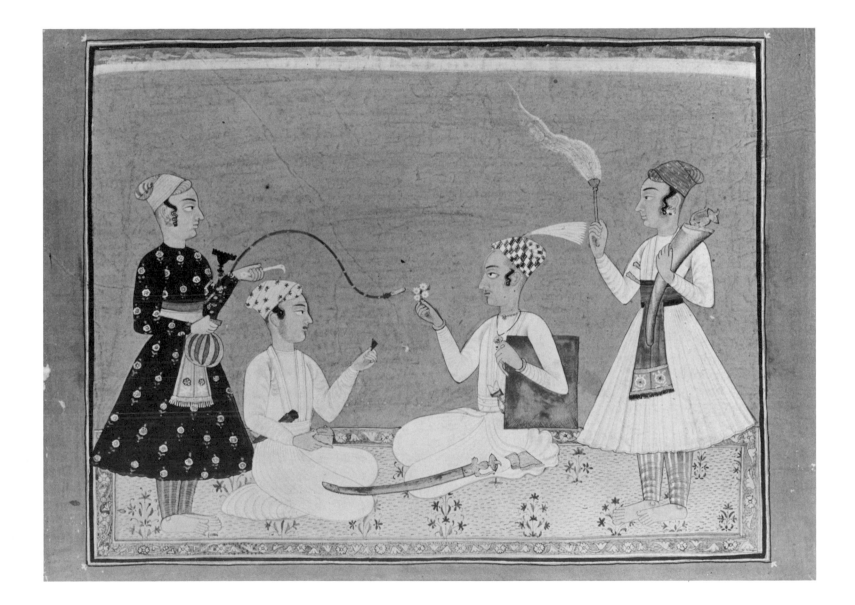

BAGHAL (ARKI), C. 1700

2. *Vilavali Ragini*

From a *Pahari Ragamala* series
$8^{1}/_{4} \times 7^{1}/_{4}$ in. (with borders)

In many Hill States, listening to music was a courtly pas-
time that had long preceded the introduction of miniature
painting. Themes or tunes were symbolized by means of
verses describing gallants, ladies in love and other per-
sonages and this had led in almost every part of India to
the production of sets of verses known as *Ragamalas* or
"garlands of tunes." In the Punjab Plains, a standard set
included six *Ragas* or "musical princes," each with five
Raginis or "consorts," making a total of thirty-six. In
Rajasthan, the number was at times increased to forty-
two. In the Punjab Hills, on the other hand, the Plains
system of thirty-six was rarely followed and instead a
special Pahari classification of eighty-four was favored.
The number of *Ragas* and *Raginis* remained constant but
each *Raga* was endowed with eight *Putras* or "sons"—
also known as *Ragas*—each of whom reflected even
finer subdivisions of the dominant mode or melody.

In the present picture, Vilavali *Ragini*, a consort of
Bhairava *Raga*, is represented by a lady, alone in a small
pavilion, distracting a child with a lotus flower while
another child, a little older, watches their over-earnest
play. The pavilion has a dull brown veranda floor and
pilasters but its flat roof, sharp and astringent like an
angular pool of deepest blue, slashes the dark red back-
ground and gives to this quiet scene a somber vigor.

Publ.: Archer, *Indian Paintings from the Punjab Hills* (1973),
Baghal no. 2(iii).

4

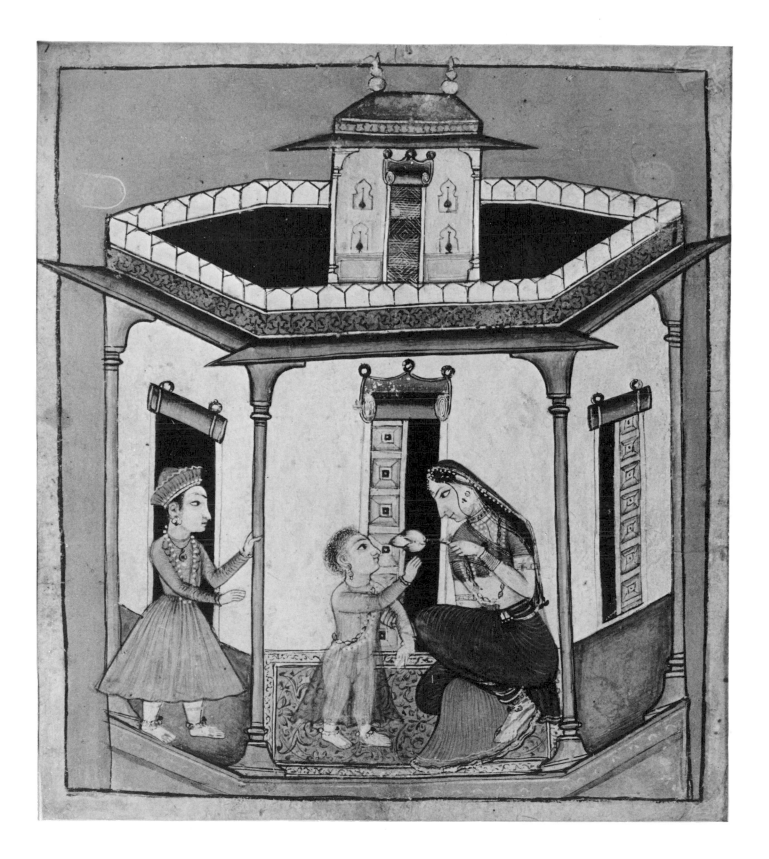

BAGHAL (ARKI), C. 1700

3. *Gaur Malhara Ragini*

From a *Pahari Ragamala* series
$7^{1}/_{2} \times 6^{3}/_{4}$ in.

This picture is from the same series as 2. Here, a lady, the consort of Megh *Raga* (a prince connected with the Rains), is enduring the lonely longing associated with the season. As she wanly sniffs a flower, her two companions parallel with hand-drum and cymbals the roar of thunder and clash of lightning. Above them, a broad band of scarlet—sharply evocative of passion—accentuates the chilly bleakness of the empty wall. The three women have the long heads and gaunt, grave faces, marked with single strands of hair, which give to early Baghal paintings a slight air of drab staidness.

Publ.: Mildred Archer, *Indian Paintings from Court, Town and Village* (1970), pl. 21; W. G. Archer, *Indian Paintings from the Punjab Hills* (1973), Baghal no. 2(ii).

6

BAGHAL (ARKI), C. 1740

4. *A Son Takes Leave*

8³/₄ × 12 in.
Misinscribed on the reverse in English: *Sham Sher
 Seen*

This is a picture in obvious Baghal (Arki) style but seemingly recording a Mandi family event. The central figure, dressed in white and clutching the stem of a hookah, bears little or no resemblance to Raja Shamsher Sen (1727–1781) of Mandi but the fact that he is named in the late inscription supports the conclusion that members of the Mandi house are in some way involved in what is clearly a highly intimate act. It is noteworthy that all the male figures wear the heavy, flat turbans which were favored at Mandi in the reign of Raja Sidh Sen (1684–1727) and were totally different in style from turbans worn at Baghal. Moreover, the long side-locks affected by all the male personages except the presiding figure and the two young boys are in the fashion popular with young men at Mandi in the seventeen-forties.

In contrast, the lady seated behind the young prince whose chin is being stroked has a typical Baghal profile; and the loosely meandering composition, the startling use of red, yellow, green and a very distinctive slate blue, as well as the strange emphasis on caressing fingers—a special Baghal trait—strongly suggest that the picture was painted at Arki, the Baghal capital. Since the party itself has a Mandi aura, the occasion must almost certainly have been some kind of ceremonial or formal visit paid to Baghal by a branch of the Mandi royal family.

What the occasion was can only be surmised, but the red costume of the kneeling prince, his hands pressed together in dutiful respect, the air of straining expectancy shared by the whole gathering, and the yearning intensity with which the young man gazes at the older personage, who gently cups his chin, suggest that he is a son already married or about to be married and is in the act of receiving a farewell blessing. Although it was usual for male members of noble families in the Hills to marry in their own states, circumstances such as a glut of sons in a particular family might force a youth to move to another State. In such cases, the young bridegroom would settle on his bride's estate and would thus be "abandoned" by his parents.

The fact that every person present wears a huge Shaiva tilak mark on the forehead suggests that the occasion demanded the approval of Shiva, a prudent precaution when a person was embarking on a major enterprise or adventure.

8

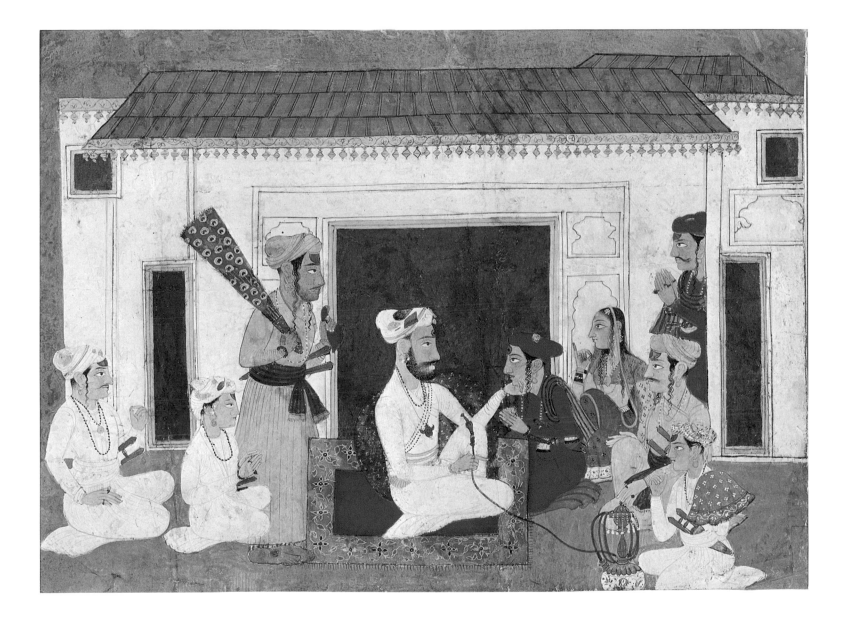

BASOHLI

BASOHLI, C. 1660–1670

5. *The Devi Rides in State*

$7^{1}/_{4} \times 10^{3}/_{4}$ in.

"Bare, ruined choirs where late the sweet birds sang." As I climbed the dusty hillside in 1960, the smell of ordure rankling in my nostrils and above me a long line of crumbling parapets, I could hardly believe that only a century ago the palace at Basohli was still regarded as one of the Seven Wonders of the Hills. To the traveler Vigne, it rose from "the dark masses of the lower ranges" with a grandeur "not inferior to that of Heidelberg" and in 1931, French could still describe it as "a beautiful old place perched on a small plateau on a hill-top and magnificently situated." In 1960 rubble was everywhere and I searched in vain for the Rang and Sish Mahals that Raja Mahendra Pal (1806–1813) had added. These had been embellished with erotic murals based on the *Koka Shastra*. They had long since vanished and all that now remained of wall paintings were a few flowers loosely scrawled on a broken arch.

With so strong a fortress palace, the state of Basohli—some twenty miles long and fifteen miles wide—had been a major power in much of the seventeenth and early eighteenth centuries. Raja Sangram Pal (1635 – c. 1673) was closely linked to the imperial Mughal court of Shah Jahan and, possibly with the Emperor's connivance, became one of the strongest warlords in the western Hills.

Under Sangram Pal's aegis, ardent Vaishnavism—a cult of instant salvation through praise and love of God—infiltrated into the Basohli court. It was, at first, resented by orthodox believers in Vishnu, Shiva and the Devi but was later accepted, after a brief transitional period, as a valid supplement to conventional worship.

This picture, a magnificent tribute to the Devi, testifies to the compromises that were necessary. Prior to the introduction of ardent Vaishnavism, there is no evidence of painting at Basohli. After its arrival, paintings of Radha and Krishna began to appear and, perhaps as a tactful sop to orthodoxy, Shiva and the Devi were first accorded visual homage. In Hindu mythology, the Devi in her form of Chandi created herself out of the anger of the three great gods—Vishnu, Shiva and Brahma—who had then no option but to worship her. It is no surprise that in another picture of this period, the Devi should be shown holding court and that Vishnu should appear in the front rank worshiping her.

The present picture, one of the earliest Basohli paintings so far known, shows the new style at the very acme of its brilliance. Other styles from Rajasthan and central India provide dim parallels but none unites the same elements of masterly assurance, glowing color, rhythmical majesty, linear sensitivity and calm, barbaric richness. Here is the Devi in all her regal might, her splendor shown in details such as the lotus crown, the umbrella with bent handle, the keenly watchful attendants and the profuse display of beetle-wing cases representing emeralds. Her warlike attributes are expressed by the drawn swords which she and her seated attendant brandish and by the sword and lance, displayed with orderly ferocity, by the second attendant who strides ahead. Even the great tigers drawing the lumbering chariot have their own majestic poise, as if they also reflected the Devi's luster and were proud to serve her. Fearsome as this sinister pageantry may seem, its tone of savage butchery is made acceptable—and even exhilarating—by the all-pervading air of stern and disciplined composure.

Publ.: Ajit Ghose, "The Basohli School of Rajput Painting," *Rupam* (1929), no. 37, fig. 7; Archer, *Indian Paintings from the Punjab Hills* (1973), Basohli no. 2.

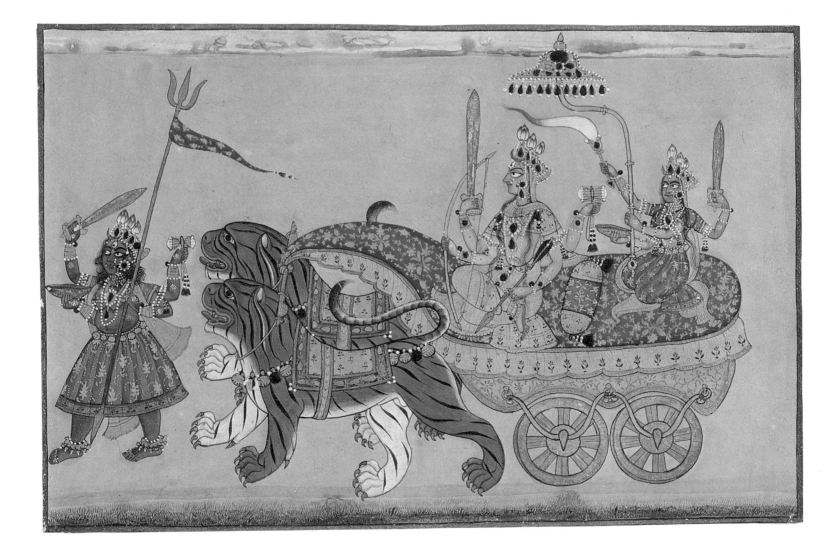

BASOHLI, C. 1675–1680

6. *Shiva and the Devi on the Bull Nandi*

4¼ × 2¼ in.

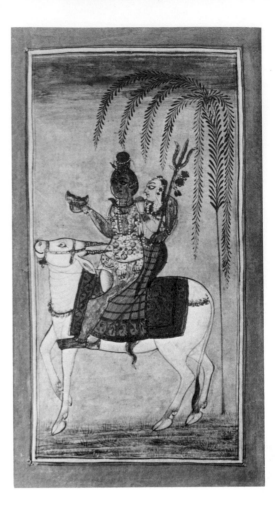

Besides the Devi, her consort Shiva was widely worshiped in the Punjab Hills. The couple's favors were regarded as indispensable for victory in battle, and as a consequence feudal rulers often made special offerings before engaging in the hazards of war. It was not for nothing that Raja Sangram Pal, besides adhering to ardent Vaishnavism, also patronized a Shaiva temple in Basohli itself.

Here, the Devi in the form of Parvati—"daughter of the mountain"—gazes ardently at her partner, as they calmly ride together on the white bull. Shiva, with ascetic gray skin, piled-up hair and spearlike trident, holds a calabash. The Devi herself wears a red skirt, an indication of her lust for blood. The picture is so tiny that it might even have accompanied its owner into battle as a midget talisman. It could well be the smallest Basohli painting in existence.

BASOHLI, C. 1690–1695

7. *Panchama Raga*

From a *Pahari Ragamala* series
8¼ × 8 in. (with borders)
Inscribed at the top in *takri* characters: *pancham raga bhairava de putra* "Pancham Raga, son of Bhairava Raga"

In this celebration of idyllic peace, a bearded prince caresses with his forefinger the chin of a blackbuck which thrusts its neck towards him. A pair of does, magnetized by the same calm presence, follow. The prince, with long red scarf entwined about his body, gazes at the herd with lingering wonder. While the bed of leaves on which he sits is wilfully enlarged, the trees which half-encircle him have dwindled to a small and lushly sprouting ring. It was the use of free poetic distortions, the glowing vitality of sparkling backgrounds and the power with which component parts were welded into a rhythmical unity that gave early painting in Basohli its supreme air of calm authority.

Publ.: Archer, *Indian Paintings from the Punjab Hills* (1973), Basohli no. 14(ii).

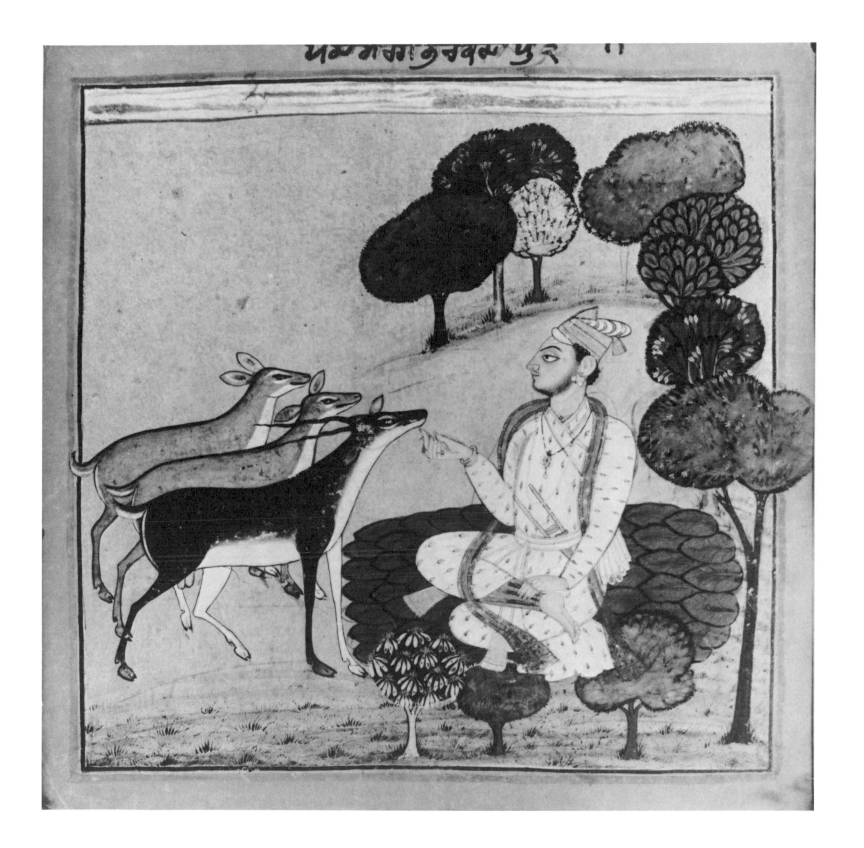

8. *Krishna Lectures the Cowgirls*

From a "fifth" *Bhagavata Purana* series
9 × 13 in.

Although ardent Vaishnavism was first brought to Basohli at the time of Sangram Pal, it was not until the reigns of his two successors—his step-brother Hindal Pal (c. 1673–1678) and the latter's son, Kirpal Pal (1678–1693)—that Vaishnava texts were openly illustrated. The most important of these were the tenth and eleventh books of the *Bhagavata Purana* in which Krishna's life among the cowherds of Brindaban, his amours with the cowgirls and his subsequent career as a feudal prince were vividly described. In about 1675 to 1680, a "first" *Bhagavata Purana* series was produced and during the years 1680 and 1690 it was followed by at least three others.[1] At the same time, individual pictures of Radha and Krishna were made and the cult reached its apogee in painting with the production in 1730–1735 of a *Gita Govinda* series. This was commissioned by a certain Lady Malini from a young Guler painter, Manaku, who by then was working at the Basohli court.

Manak (or Manaku, as he was familiarly called) had adjusted himself to Basohli society and his illustrations of Jayadeva's famous poem (the *Gita Govinda*) in praise of Radha and Krishna were painted in a style which combined the hot magnificence of previous Basohli painting with greater simplification, muted ferocity and milder naturalism. Beetle-wing cases, however, were still used for emeralds and his pictures glow and flash with Basohliesque bravura.

We do not know how long Manaku remained at the Basohli court and indeed the whole of his later career is a matter for surmise. We know, however, that his younger brother Nainsukh joined the entourage of Raja Amrit Pal (1757–1778) of Basohli after the death of his greatly loved patron, Balwant Singh of Jammu in 1763 (see 31). At some time Nainsukh was vested with lands in the Basohli state and his youngest and fourth son, Ranjha, appears to have been brought up on them. Nainsukh himself remained with Amrit Pal until their joint deaths in the year 1778.

After joining Amrit Pal, Nainsukh does not seem to have produced much work and in fact, like the painter Mola Ram of Garhwal, his role may have gradually evolved into that of courtier, confidant and trusted adviser. Yet his genius as an artist could hardly have atrophied entirely, and it seems possible that, under his direction and with his own occasional collaboration, a "fifth" Basohli *Bhagavata Purana* was executed. The result was the series from which the present and following two pictures are taken.

Two influences are clearly present. The first is Manaku's, whose *Gita Govinda* series provides in places the exact models for pictures in the present *Bhagavata Purana*. Manaku himself can hardly have done them but his eldest son, Fattu, may conceivably have absorbed his father's early technique and applied himself to the new project. Acquaintanceship with Nainsukh's style of relaxed portraiture cannot have been ignored and in fact traces of Nainsukh's unique idioms are at times clearly visible. What seems likely, therefore, is that Fattu diluted still further Manaku's *Gita Govinda* style with Guler naturalism. At the same time, Nainsukh may have proffered sage advice and even undertaken certain *tours de force*.

The present picture is typical of Fattu and is a logical development out of his father's *Gita Govinda*. Krishna has beguiled the married cowgirls with his flute, has summoned them to a tryst in the forest and then, under the glaring light of the full moon, is reprimanding them for audaciously abandoning their husbands. The girls are at a loss to understand his "trickery" as he sternly lectures them on the virtues of conjugal fidelity. The mood, however, sharply changes, and when they declare their unshakeable devotion, he agrees to accept them as his lovers

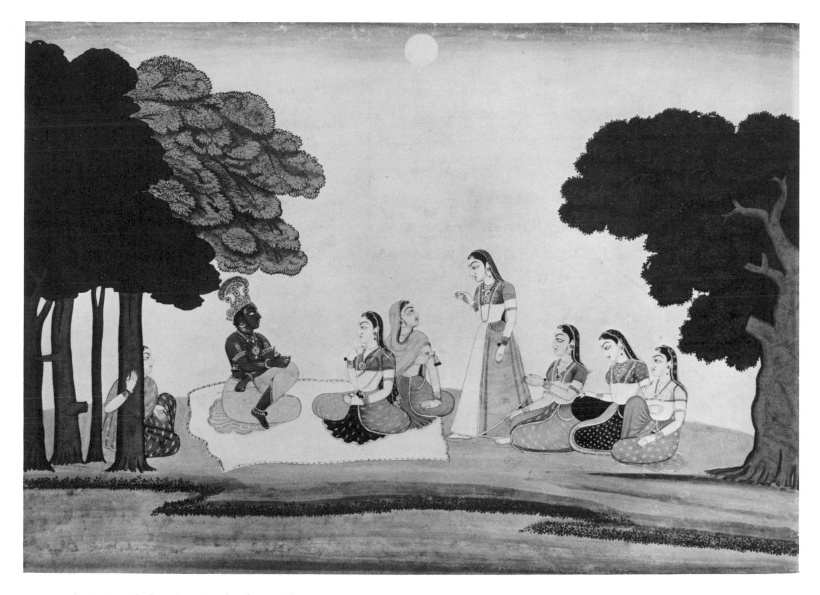

and to join with them in a circular dance. The picture records the moment at which negotiations appear to be breaking down and it is only the white, clear moon poised high in the sky that provides an image of steadfast loyalty.

1. For details of the Basohli *Gita Govinda* of 1730–1735 and of the first "five" Basohli *Bhagavata Puranas*, see Archer, *Indian Paintings from the Punjab Hills* (1973), Basohli nos. 6, 8, 12, 12(2), 18, 22.

Publ.: Mildred Archer, *Indian Paintings from Court, Town and Village* (1970), pl. 27.

BASOHLI, C. 1760–1765

9. *The Burning Hill*

From a "fifth" *Bhagavata Purana* series
11 × 15 in.

Following his ultimate departure from Brindaban, his killing of the demon king Kansa and assumption of his role as feudal prince, Krishna endeavors to reestablish his own people, the Yadava community, in Mathura. Two of Kansa's widows, however, are daughters of Jarasandha, a demon king of Magadha, and at their instance Jarasandha mobilizes a large army and invests the city. Krishna and Balarama are undismayed. They attack the demon horde single-handed, rout it, take Jarasandha prisoner but release him so that he may return to the attack and yet more demons can be slain.

After seventeen defeats of Jarasandha, a second demon king, Kaljaman, attempts to exterminate the Yadavas (see 68). This time Krishna evacuates Mathura, conveys its inhabitants to a new city, especially made for them at Dwarka on the western seaboard, and returning with Balarama eliminates Kaljaman and his forces.

They are now alone in Mathura ready for Jarasandha's last and eighteenth attempt. They decide to trick him, and pretending to be utterly vanquished, they run from Mathura and ascend a steep hill. The demon armies surround it and there appears to be no possible means of escape. Jarasandha orders wood to be brought, piled up round the hill, saturated with oil and then set light to. Flames shoot up but Krishna and Balarama leap from the blaze and slip away unnoticed. They take the road to Mathura and finally rejoin their kinsmen in Dwarka. When the hill is reduced to ashes, Jarasandha concludes that Krishna and Balarama have perished. Some years later they will meet again and Krishna will kill him.

The picture shows a small detachment of Jarasandha's martial horde surrounding the burning hill at the moment when the white-skinned Balarama streaks for safety and Krishna takes the final leap.

Publ.: Mildred Archer, *Indian Miniatures and Folk Paintings* (1967), pl. 26.

16

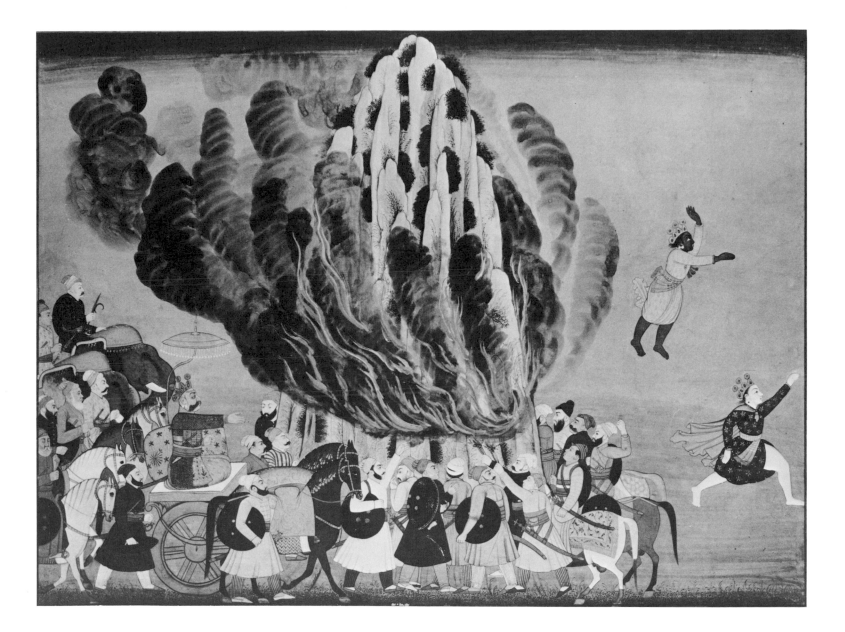

BASOHLI, C. 1760–1765
By Nainsukh (?)

10. *The House of the Pandavas Is Set on Fire*

From a "fifth" *Bhagavata Purana* series
$10^1/_4 \times 14^1/_2$ in.

The house of the Pandavas, seen dimly in the background against a dark blue sky, powdered with stars, is surrounded by a whirling flurry of red and yellow flames. Nainsukh is clearly not the principal artist of this large series, but only a painter of his genius could have treated so furious a conflagration with such consummate skill.

That Nainsukh may indeed have been the artist is suggested by two other paintings, where he renders night scenes with the same uncanny flair, and by a third picture, *An Allegory of Disaster*, which shows flames engulfing a building in a raging inferno, and where the subject is his patron, Raja Balwant Singh of Jammu (see 31).[1]

For the role of the Pandavas in the story of Krishna and the circumstances in which a plot to murder them by firing their house is foiled, see W. G. Archer, *The Loves of Krishna* (Grove Press, New York), pp. 20–21.

1. Archer, *Indian Paintings from the Punjab Hills* (1973), Jammu nos. 43, 43(1) and 53.

Publ.: G. Lawrence, *Indian Art: Paintings of the Himalayan States* (1963), col. pl. 10; Mildred Archer, W. G. Archer and Sherman E. Lee, *Indian Miniatures from the Collection of Mildred and W. G. Archer, London* (1963), pl. 73; Mildred Archer, "Indian Miniatures," *Art International* (1963), VII, no. 9, 23; Mildred Archer and W. G. Archer, *Romance and Poetry in Indian Painting* (Wildenstein Exhibition, London, 1965), pl. 72; Archer, *Indian Paintings from the Punjab Hills* (1973), Basohli no. 22(xiii).

18

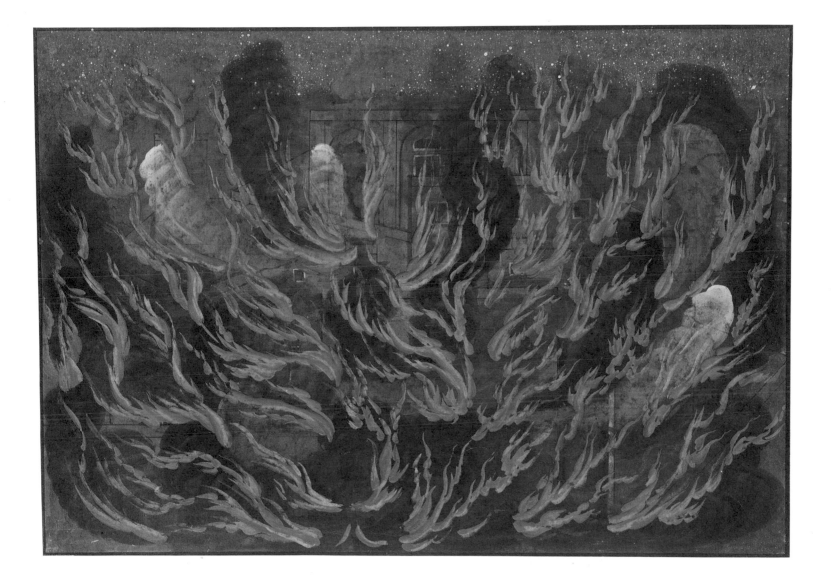

CHAMBA

11. *The Princes Confer*

$6^1/_4 \times 10^1/_4$ in.

Inscribed at the top in takri characters:
 (1) *chambyal mian ragunath singh*;
 (2) *kastwaria mian sirdar singh*

In contrast to Baghal and Basohli, both of which were easily approachable from the Punjab Plains, Chamba was a huge state, sixty-five miles long by fifty miles wide, composed of precipitous hills and bounded on one side by the glistening white of the Dauladhar range of mountains. Since its capital lay to the west, its principal relations were with states in the Jammu orbit.

The picture shows Raghunath Singh of Chamba on the left conferring with Sirdar Singh of Kashtwar, a state that lay to the north of Chamba. Raghunath Singh was the fifth younger brother of Raja Chattar Singh (1664–1690) of Chamba, who had successfully invaded Kashtwar and annexed part of its territory. Sirdar Singh had commanded the Kashtwar army but had suffered defeat. The two princes may here be discussing peace terms: the smug arrogance with which Raghunath Singh toys with his hoo-

kah as he grimly surveys his visitor suggests this situation.

The present picture, with its yellow ochre background typical of Chamba painting, is enlivened by the mauve rug with green stripes on which the rival princes are sitting. Each is dressed in white but a marked feature is the use of bold ribbonlike stripes, gray in the case of Raghunath Singh on the left, red in the case of Sirdar Singh on the right. The two rectangular white cushions on which they are leaning emphasize the rigid fixity of their postures—a fixity the more evident because of the many vertical and horizontal lines with which their two costumes are striated. Hieratic simplicity was characteristic of early Chamba painting and may have been taken from its neighbor Mankot, where a vigorous school of portraiture in broadly similar style flourished in the period 1670–1700.

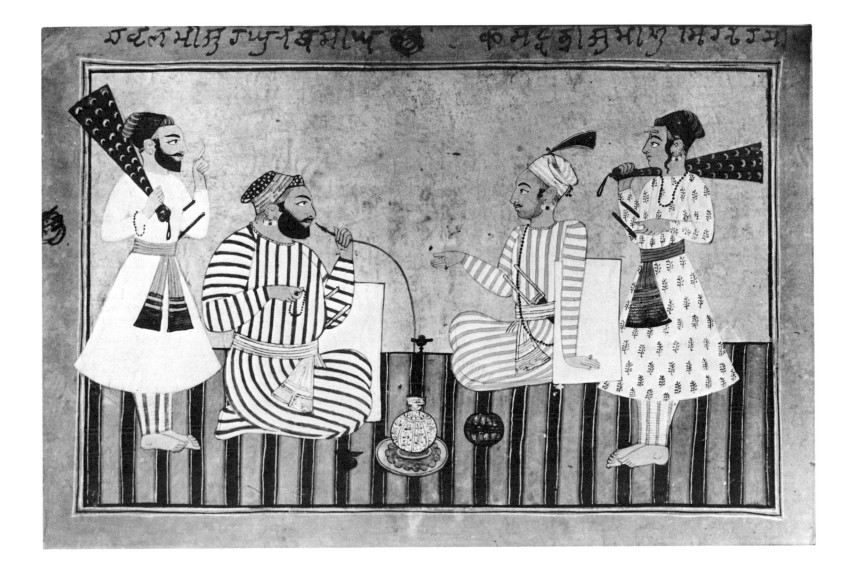

CHAMBA, C. 1760

12. *The Lady with the Hookah*

$8\frac{1}{4} \times 7$ in. (with borders)

Under Raja Umed Singh (1735–1764) of Chamba, local artists experimented with different types of female face and at the same time evolved a style of stark and simple spaciousness. The chocolate brown background is as un-relieved as the white terrace, and both princess and maids have simple dresses with the very minimum of decoration. As in the work of Laharu, a Chamba painter of moderate attainments, named on a single page of a *Ramayana* series dated 1757,[1] much of the early stiffness of Chamba painting persists, but the long trailing dresses and undulating hookah-stem hint at the graceful elongations of physique which were shortly to appear.

1. Archer, *Indian Paintings from the Punjab Hills* (1973), Chamba no. 18.

Publ.: Archer, *Indian Paintings from the Punjab Hills* (1973), Chamba no. 23.

CHAMBA, C. 1765

13. *Rama and Sita with Lakshmana and Hanuman*

$9 \times 6\frac{1}{2}$ in.

As in Kahlur (Bilaspur) and Kulu, royal worship at Chamba centered on the cult of Rama. According to tradition, the ruling family was directly descended from Vishnu through Rama's second son, Kusha. A sense of lively identification with Rama was certainly present, and this had led to the construction in the twelfth century of the Lakshmi Narain temple which towers above the houses in Chamba town.

In 1645 the Mughal Emperor Shah Jahan presented Raja Prithvi Singh (1641–1664) of Chamba with a stone image used as a weight in the imperial palace, and this was named Raghubir (Rama) and installed as the family idol. In 1678 the Emperor Aurangzeb demanded the destruction of the temple but the son of Prithvi Singh, Raja Chattar Singh (1664–1690), curtly defied him. Chattar Singh's personal devotion to Rama was reflected in a painting which shows him standing before a shrine containing images of Rama and Sita seated on a throne with Lakshmana and Bharata standing on either side.[1] The present picture parallels this record of worship by showing Rama and Sita on a low dais, Lakshmana on the floor in front and Hanuman in red trunks standing behind them with a peacock-feather fan like a faithful chaprassi.

Although sharing the empty spaciousness of the earlier picture, this painting contains a new element of stylish elegance. The faces are based on Guler models which could well have been introduced by immigrant Guler painters in the years 1760–1770. There are nonetheless distinctive Chamba ingredients—the use of a typical head idiom for Rama, square-shaped with a roll of curl at the nape of the neck, and oval thighs that signal to each other across the picture.

1. Archer, *Indian Paintings from the Punjab Hills* (1973), Chamba no. 2.

Publ.: Archer, *Indian Paintings from the Punjab Hills* (1973), Chamba no. 30.

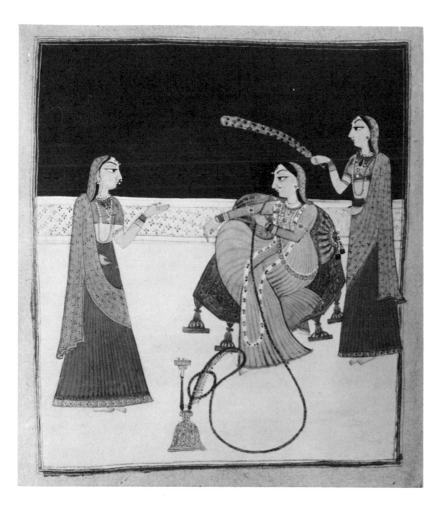

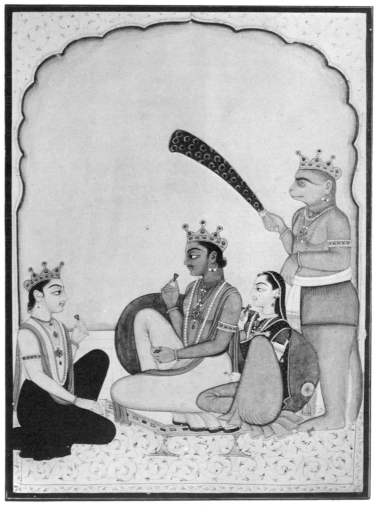

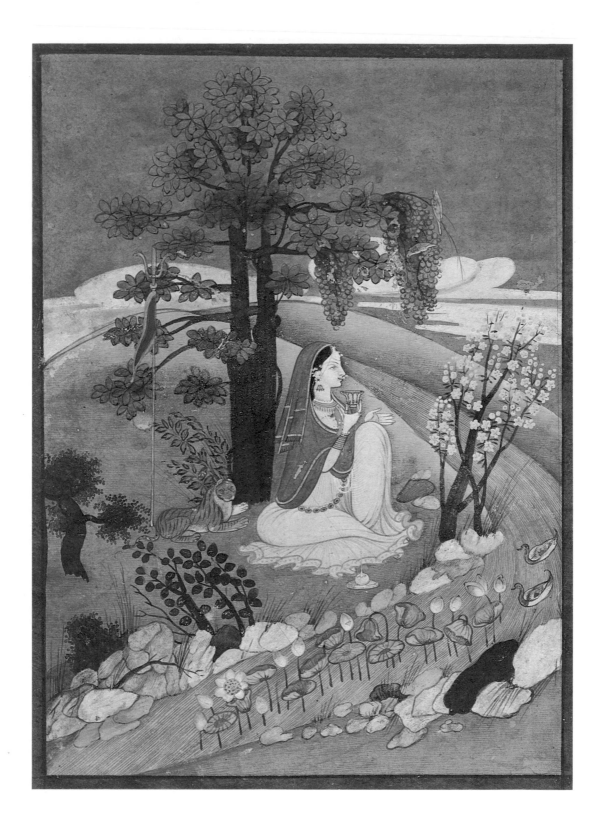

GARHWAL

GARHWAL, C. 1785

14. *Parvati Alone*

$7^1/_4 \times 5^1/_4$ in.
Inscribed in *nagari* characters on the reverse:
kailashnath parvati

Lying at the extreme southeast of the Punjab Hills, Garhwal was 160 miles long and 110 miles wide. It was thus by far the largest state in the Pahari area. A trade route to the north connected it with Nahan (Sirmur), Bilaspur (Kahlur), Guler and Jammu, and this may explain the arrival of a Guler master-artist at the Garhwal capital, Srinagar, in about the year 1765 or a little later. He was probably accompanied by one or more assistants and the result was a local school of painting that combined the tranquil grace and serene elegance of painting in Guler with idioms suggested by the local environment. Deep blue skies, sinuous branches, trees with star-shaped flowers and water with swirling eddies were only some of the features which differentiated painting in Garhwal from its original Guler source.

In this picture—an exercise in grave serenity—Parvati, "daughter of the mountain," sits gazing out over a stream which hurtles down a hillside in a sharp bend beside her.

Boulders, lotuses and trees jostle each other in wild confusion, but she herself is wholly calm. She holds a fragile cup, perhaps containing the narcotic drink which she has prepared for her husband, Shiva. Her sari, pale blue edged with pink, challenges with lyrical delicacy the dark blue veil that shrouds her head and shoulders. Behind her sits a tiger cub.

As in much Garhwal painting, the sky is a deep blue relieved only by a low line of white clouds gashed with red. Red is also the color of the pennant which droops from the long trident-headed spear planted in the ground beside her. Over everything broods a great tree with twin trunks, emblematic of her union with Shiva, its steadfast poise providing "the still centre" of a lonely troubled world.

Publ.: Mildred Archer, W. G. Archer and Sherman E. Lee, *Indian Miniatures from the Collection of Mildred and W. G. Archer, London* (1963), pl. 59.

GARHWAL, C. 1780–1790

15. *Winter*

The month of *Magh* (January to February) from a
Baramasa series
$7\frac{1}{2} \times 5\frac{1}{4}$ in.

Baramasa paintings, illustrating the moods and encounters of lovers during each of the twelve months, were a poetic means of interpreting courtly passion. The lovers are Radha and Krishna, supreme exemplars of romance and by their very selection associating courtly love with religious fervor. In each of the twelve pictures, the same two protagonists appear but subtle changes of detail indicate the passage of the seasons.

Here the lovers are wrapped in orange red shawls, the chill of winter keeps them stiffly apart, the hard-edged hillside has a numbing dullness and the shrunken village at the top slumps under a freezing white sky. There is nonetheless a haunting sense of quiet rapture as the lovers gaze at each other, calmly unaware of the windless cold.

Publ.: W. G. Archer and Deben Bhattacharya, *Love Songs of Vidyapati* (1963), pl. 1; Mildred Archer and W. G. Archer, *Romance and Poetry in Indian Painting* (1965), pl. 51; Archer, *Pahari Miniatures: A Concise History* (1975), col. pl. 37.

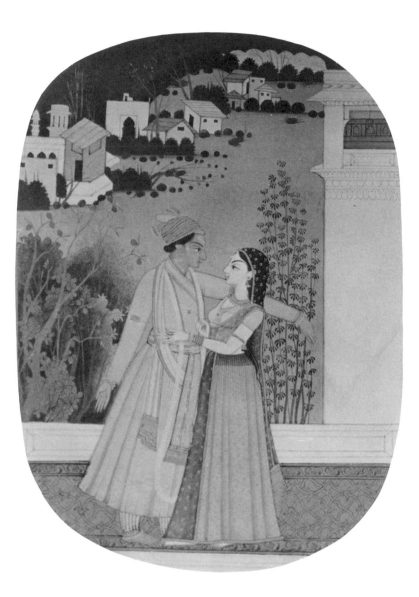

GARHWAL, C. 1780–1790

16. *Spring*

 The month of *Phagun* (February to March) from
 the same *Baramasa* series as 15
 $7\frac{1}{2} \times 5\frac{1}{4}$ in.

The chilly atmosphere of the previous picture has van-
ished. Spring has come, the hamlet is more in evidence,
trees have burst into fresh leaf, a bush shoots radiantly
upwards and the scene has shifted to a terrace with a
proud white tower topped by a lovers' chamber. Radha
and Krishna, no longer wrapped in shawls, have drawn
closer. Krishna flaunts a sunny yellow *jama*, expressive
of the gay heats of spring and his arms, flung widely apart,
invite bold embraces.

Publ.: W. G. Archer and Deben Bhattacharya, *Love Songs of Vid-
yapati* (1963), fig. 11 (detail); Mildred Archer, W. G. Archer and
Sherman E. Lee, *Indian Miniatures from the Collection of Mildred
and W. G. Archer, London* (1963), pl. 57; Archer, *Indian Paintings
from the Punjab Hills* (1973), Garhwal no. 5(iii) col.

GARHWAL, C. 1785

17. *Sages in a Landscape*

From a *Markandeya Purana* series
$7 \times 9^{1}/_{2}$ in.
Inscribed on reverse in Sanskrit verses in *nagari*
 characters: "Jaimuni questions Markandeya
 Mahamuni (great sage), disciple of Vyasa, who
 is possessed of great powers and who is
 engaged in asceticism"

This is the opening illustration to a religious text celebrating the Devi, the "great goddess," consort and partner of Shiva. The white-haired sage is Markandeya, the black-bearded one Jaimuni.

In the picture, the great trees studded with starlike blossoms reveal the simple boldness with which a lesser painter at Garhwal applied the master-artist's inventions. The flat expanse of flaming scarlet derives immediately from Guler, proving how, even in a new environment, Guler artists could not wholly discard their customary devices. As a background to the forest, rioting with white and yellow flowers, the use of red provides a tart allusion to the tumult of the senses. To overcome passionate sensuality and thus achieve peace of mind, Indian sages or holy men would often settle in remote places where peace and isolation—despite the lyrical glory of the forest—would strengthen their resolves.

Publ.: W. G. Archer, *Indian Miniatures* (1960), col. pl. 96.

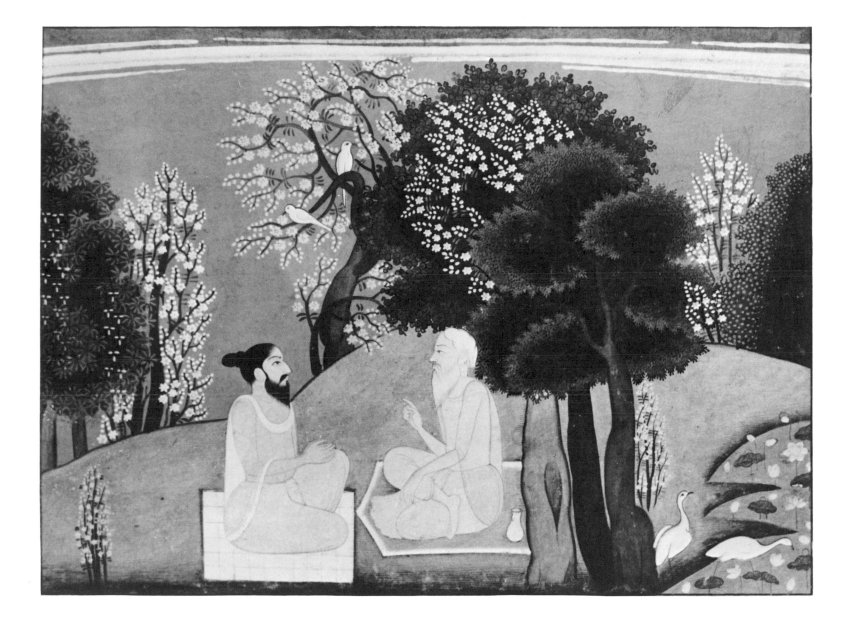

GARHWAL, C. 1790

18. *The Great Deceiver*

$7^3/_4 \times 5$ in.

Against a background of "Garhwal" colors and a tree full of star-shaped "Garhwal" flowers, the lovers stand confronted. Krishna, having spent the night elsewhere, approaches cautiously. Radha, after vainly awaiting him, stands scornful and incredulous. Dawn is breaking and the sun, tentatively appearing above the horizon, mimics Krishna's hesitant arrival.

In Indian erotics, the situation is not unfamiliar and the final outcome may be expected to parallel in Indian terms the reconciliation described by the Latin poet Propertius in Gilbert Highet's translation:

Those were her conditions. "I accept," I said.
She laughed, arrogant with victory.
Then each and every spot touched by the visiting girls
She disinfected; washed the threshold clean;
Directed me to change my clothes, not once, but twice;
And touched my head three times with burning sulphur.
So, after she had changed each separate sheet and blanket,
I kissed her. We made peace, all over the bed.

Publ.: Mildred Archer, *Indian Miniatures and Folk Paintings* (1967), pl. 38.

30

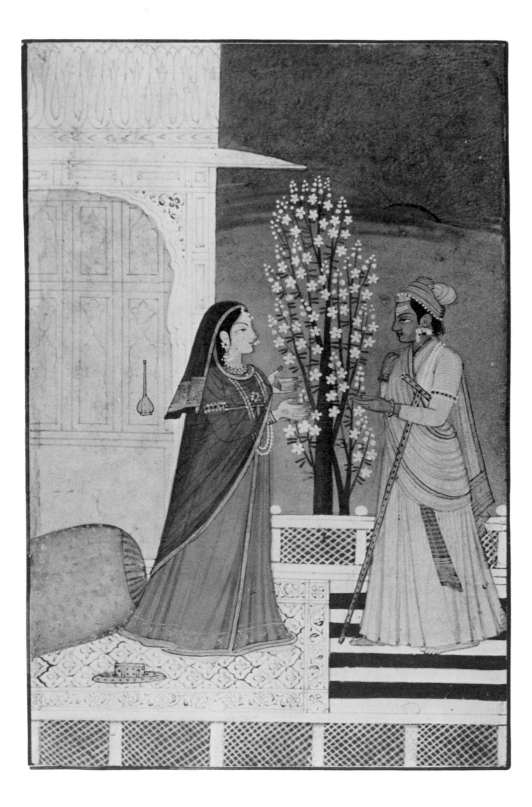

GARHWAL, C. 1790

19. *The Departure for the Shrine*

From a *Krishna Rukmini* series
$6^3/_4 \times 9^3/_4$ in.

Rukmini, on her wedding morning, sadly goes to the local shrine of the Devi to worship before her marriage. Her father has affianced her to a certain Sisupal and although she has sent messages to Krishna imploring him to save her, she is unaware of what the day will bring. A little later, Krishna will suddenly appear, rout her guards, place her in his chariot and rush her to safety. Later still, they will be formally married and Rukmini will thus become Krishna's first legal queen. The episode occurs long after Krishna's abandonment of Radha and the cowgirls, and marks a crucial stage in his later career as a feudal prince.

Here, Rukmini, in orange dress and dark red wrap, a slender hand on her cheek, is preceded by three guards, two priests with offerings and by a stately chaperon in dark blue who holds a golden stick. Behind her come six other maids, one of whom waves a white fly-whisk in token of Rukmini's royal status. A tree with large leaves extends a drooping branch above her as if in sorrow at her lot. The whole scene has an air of forlorn acquiescence in a distasteful rite and it is only the supreme elegance of Rukmini and her maids and the picture's glowing richness of coloring that imbue their doleful march with feudal grandeur.

Publ.: Mildred Archer, *Indian Miniatures and Folk Paintings* (1967), pl. 40.

32

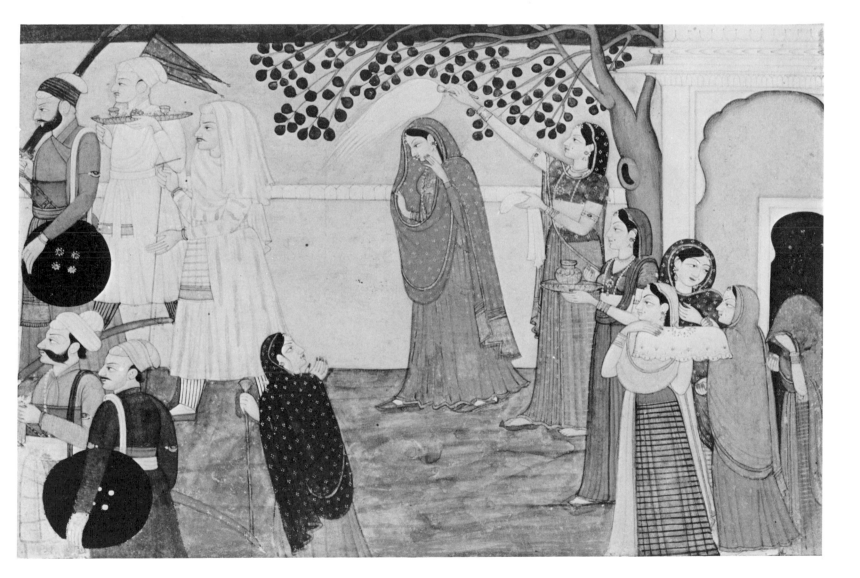

20. *Radha's Toilet*

8 × 5 ¹/₂ in.

This is an illustration to the *Sat Sai* ("seven hundred verses") of the Hindi poet Bihari in which he glorified the loves of Radha and Krishna. Watching a beloved mistress at her toilet, smoothing her hair or drying her nude skin were proofs of amorous sensitivity. Here both Radha and her maid have the perfect physiques of other women in Garhwal painting but with the important difference that their breasts are boldly apparent beneath their bodices. Although Krishna holds a cowherd's crook, a river separates him from the herds and he stands on Radha's terrace as if totally insulated from the demands of normal life.

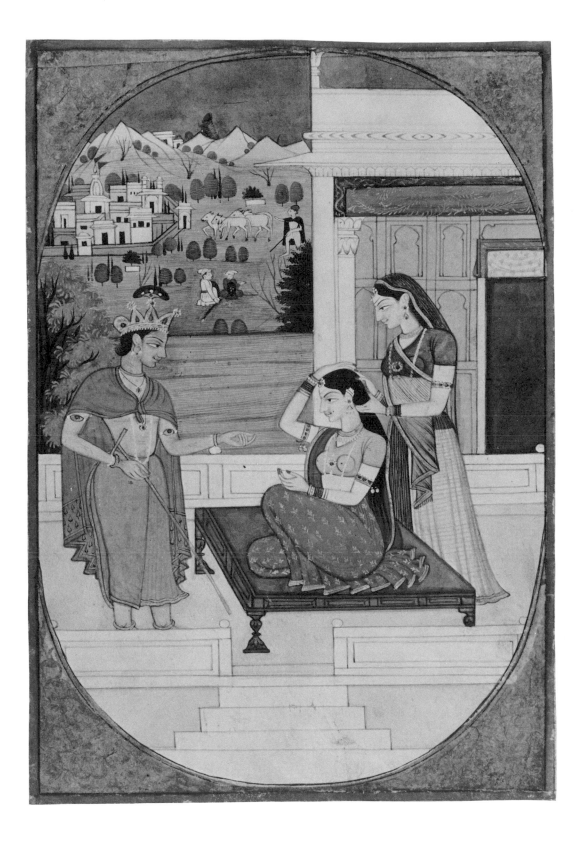

GARHWAL, C. 1800–1820

21. *Radha and Krishna on the Bed*

$11 \times 6\frac{1}{2}$ in.

In the *Gita Govinda*, the Sanskrit poem by Jayadeva, the various vicissitudes in Krishna's romance with Radha are lyrically described. Radha, after being temporarily abandoned, is wooed again and a night of love-making follows.

Although the present picture does not come from any known *Gita Govinda* series, it reflects the poem's concluding stanzas, as paraphrased by Sir William Jones (1746–1794): "In the morning, she rose disarrayed, and her eyes betrayed a night without slumber; when the yellow-robed God, who gazed on her with transport, thus meditated on her charms in his heavenly mind:

Though her locks be diffused at random, though the lustre of her lips be faded, though her garland and zone be fallen from their enchanting stations, and though she hide their places with her hands, looking towards me in bashful silence, yet even thus disarrayed she fills me with extatick delight."

In the picture, dawn is breaking, women in the far distance are picking fresh flowers, and in a further pavilion, a lonely girl raises her arms in longing. The orange red of the canopy and of Radha's gauzelike garment parallel the night's flaring passion and the pot and lota, the twin lamp shades and the flirting birds provide yet further allusions to their love-making.

Publ.: W. G. Archer, *Garhwal Painting* (1954), col. pl. 10; Mildred Archer, "Indian Miniatures," *Art International* (1963), VII, no. 9, 23; W. G. Archer and Deben Bhattacharya, *Love Songs of Vidyapati* (1963), fig. 24 (detail); Mildred Archer and W. G. Archer, *Romance and Poetry in Indian Painting* (1965), pl. 57; Mildred Archer, *Indian Miniatures and Folk Paintings* (1967), pl. 41; Archer, *Indian Paintings from the Punjab Hills* (1973), Garhwal no. 23.

36

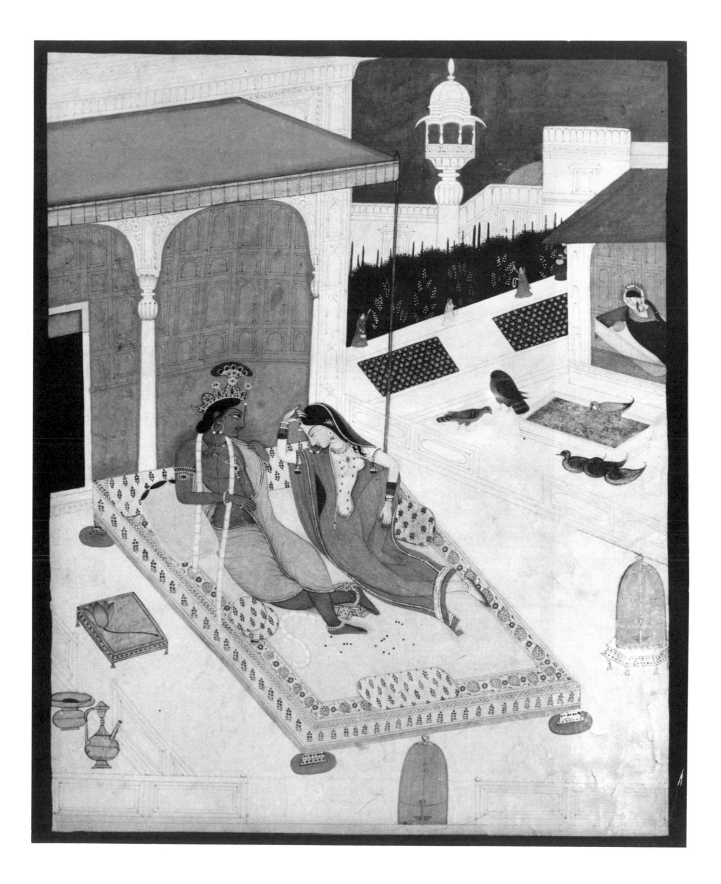

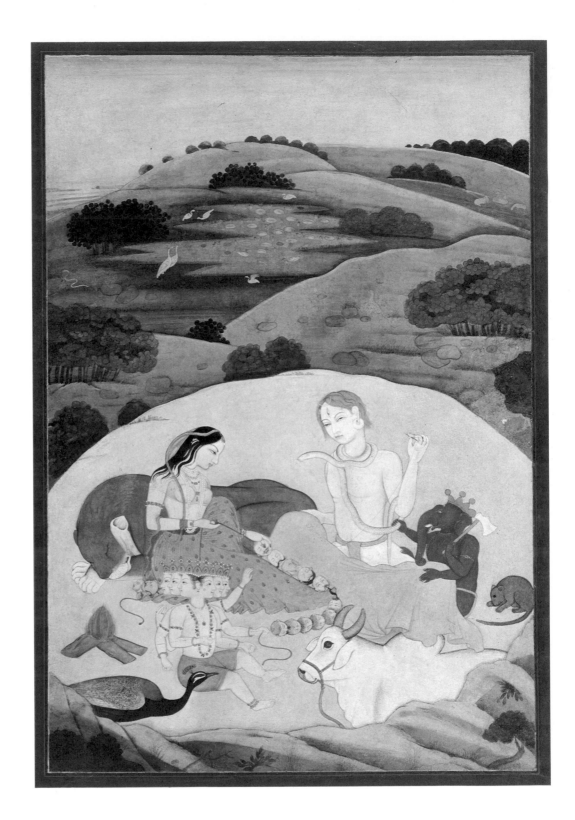

GULER

GULER, C. 1750

22. *The Holy Family*

$10^{1}/_{2} \times 7$ in.

Although a painter colony had existed in Guler, an off-shoot of Kangra, from the seventeenth century and the names and genealogy of at least one artist family are known in detail, it is one of the quirks of Indian art history that not a single Guler painting of the eighteenth century can be firmly connected with any known Guler painter. Every member of the named Guler family of artists seems to have worked outside Guler, pointing to the irresistible conclusion that other painter families must have produced the great masterpieces for which Guler is famous.

The head of the known family was a certain "Pandit" Seu (Shiva), his two sons were Manak and Nainsukh and his grandsons were Fattu and Khushala (sons of Manak) and Kama, Gaudhu, Nikka and Ranjha (sons of Nainsukh). The family's connection with Guler is abundantly proved by entries in priests' registers at Hardwar, Pehowa and other pilgrimage centers. Their training as painters could also have taken place in Guler. Nonetheless, it is with Kangra, Chamba, Jammu and Basohli—rather than with Guler itself—that particular works by them are associated. It is as propagators of Guler painting rather than as actual painters of Guler pictures that this talented family must perhaps be seen.

The present picture shows Guler painting of the mid-eighteenth century at a time when lush naturalism had superseded stark simplicity. Shiva and Parvati with their children, the elephant-headed Ganesha and the multi-headed Skanda, are engaged in small "domestic" tasks. Shiva has a needle and thread with which he is sewing a pink cloth. Parvati (a form of the fierce Devi) is stringing human heads into a necklace, assisted by her son Skanda. Ganesha, seated with his attribute, the rat, is fondling a cobra entwined round Shiva's neck, while in the foreground, Skanda's vehicle, the peacock, looks intently at Shiva's mount, the white bull Nandi. Each has a calm nobility of expression and Parvati herself displays that "deliberate research into physical charm" which Coomaraswamy regarded as one of the prime aspects of the school. Behind Parvati lies a dozing lion, its air of lazy relaxation reminding one of W. H. Auden's description of a summer evening

The lion griefs loped from the shade
And on our knees their muzzles laid
And Death put down his book.

Over everything hangs a mood of pastoral content, to which the cranes and egrets stalking by the lotus pond, the pair of cheetahs lying together and the snake peacefully slithering up a hillside make gentle contributions.

Publ.: Archer, *Indian Paintings from the Punjab Hills* (1973), Guler no. 25; Archer, *Pahari Miniatures: A Concise History* (1975), pl. 34.

GULER, C. 1760

23. *Krishna Paints Radha's Toenails*

$7 \times 4^{3}/_{4}$ in.

In contrast to more violent kinds of love-making, the painting of toenails was a significant form of quiet and gentle adoration. Involving an attitude of willing servility on the part of the lover, it enabled him to appreciate his mistress's charms by subtly assisting at her toilet. The act involved total abasement, a fact to which the maid on the left is drawing Radha's attention. The insertion of soaring cypress trees into backgrounds was a common device in Guler painting, suggesting as they did the spontaneous stirrings of desire and thus providing a symbolic setting for the lovers.

Publ.: Mildred Archer, W. G. Archer and Sherman E. Lee, *Indian Miniatures from the Mildred and W. G. Archer Collection* (1963), pl. 52; W. G. Archer and Deben Bhattacharya, *Love Songs of Vidyapati* (1965), pl. 23 (detail).

40

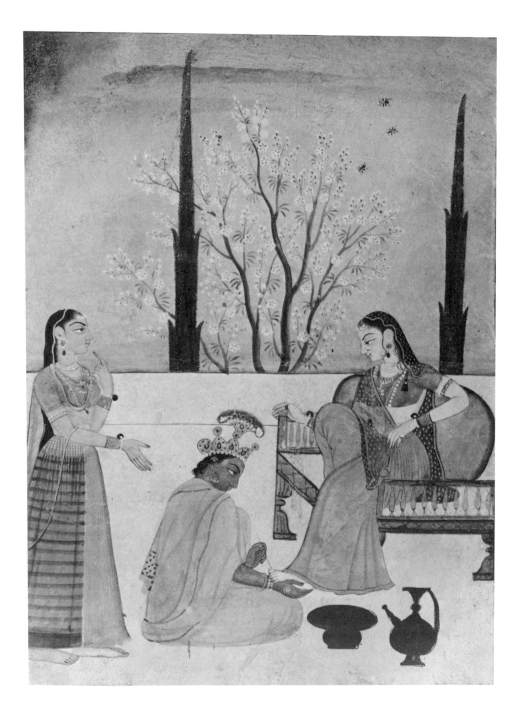

GULER, C. 1765

24. *The Lady and the Peacock*

$7\frac{1}{2} \times 4\frac{3}{4}$ in.

A lady has been waiting all night for her lover who has not come. She is about to cast away her pearls which have become so hot from the fever of unappeased desire that she cannot wear them. A peacock, symbol of the absent lover, struts beside her on a terrace, its upward straining beak dimly mimicking the substance of her thoughts. As in 23, a cypress tree rears its slender vertical form in the background. With its open sparseness, wan pallor and almost trembling delicacy, the picture typifies a form of painting in Guler which won increasing acceptance in the second half of the eighteenth century.

Publ.: Mildred Archer, *Indian Miniatures and Folk Paintings* (1967), pl. 32.

42

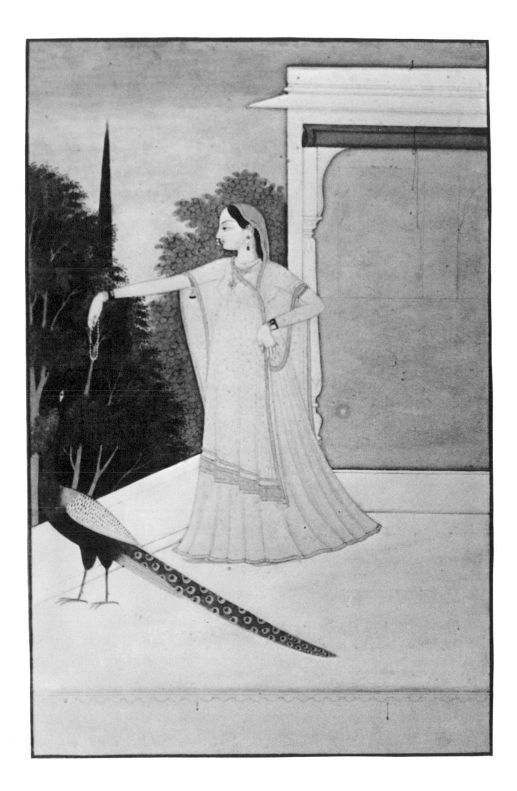

GULER, C. 1810

25. *Preparing for the Lover*

8 × 6 in.

A courtly lady is almost ready. She has taken her bath and donned a plain white dress, a golden veil that courses down her back and a pair of tightly fitting orange trousers. As she leans against a gray bolster, her left hand toying with a spray of jonquils, a maid in orange dress flicks a white handkerchief above her. Another maid brings a garland of fresh flowers and a third maid kneels before her, massaging a foot.

In terms of style, yet another Guler invention is now discernible—a face with virtually straight nose and forehead. This was a product of the seventeen-seventies and characterized Guler painting until well into the nineteenth century. The convention of a red carpet with vertical brown stripes dates from a little earlier and despite temporary supersessions, remained as firmly entrenched in Guler painting as did the "Guler" red background (see 17). The present picture has much in common with a picture of Raja Bhup Singh (1790–1820) of Guler with his ladies and, like that painting, must be dated to about 1810.[1]

1. Archer, *Indian Paintings from the Punjab Hills* (1973), Guler no. 62.

Publ.: Mildred Archer, *Indian Miniatures and Folk Paintings* (1967), pl. 33.

44

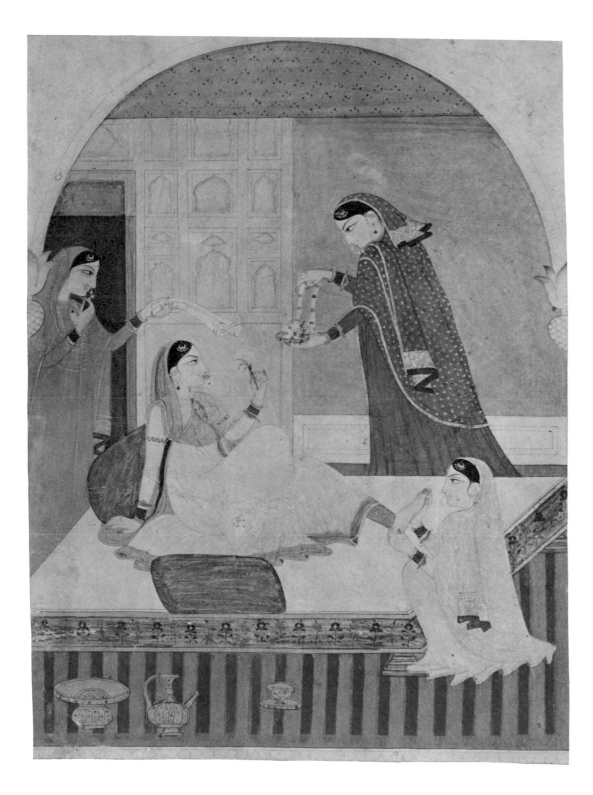

GULER, C. 1840–1850

26. *The Lady and the Plantain*

8³/₄×6 in.

When I visited Guler in 1954, plantain (banana) trees with their pendulous flowers—later to become swelling clusters of fruit—were a striking feature of Haripur town. It was no surprise to find, therefore, that in early Guler painting they had been used as almost indispensable symbols in pictures that portrayed courtly love. In Sanskrit poetry thighs were compared to plantain leaves, and a lonely woman, deprived of a lover, was supposed to clasp its smooth stem in a vain attempt to assuage her longing.

Here a lady whose face conforms to a type invented many years earlier wears sunny yellow trousers—the color of love and spring—and holds with feverish tightness its springing trunk. A flowering tree, also entwined about the plantain, parallels her action. The blue of her flowing dress is echoed in the plantain's drooping flowers, in the broad sweep of sky and in the male pigeon which shamelessly mounts its mate. The scarlet red background, by now an obvious cliché, introduces the inevitable note of clamorous passion.

It is a wry reflection on my own naiveté that, seduced by this picture's bold areas of uncompromising color—as modern as only modern art could be—fascinated also by what I then thought was Indian—and yet at the same time Freudian—imagery, I snapped it up in my first year of collecting. Only much later, with far greater experience, did I realize that it was alas! almost at the end of the road—a product of painting under Mian Jai Singh (1822–1884) by whose lifetime the marvelous flowering of painting under Raja Govardhan Chand (1741–1773) of Guler was long since over.

Publ.: Mildred Archer, *Indian Miniatures and Folk Paintings* (1967), pl. 34; Archer, *Indian Paintings from the Punjab Hills* (1973), Guler no. 75.

46

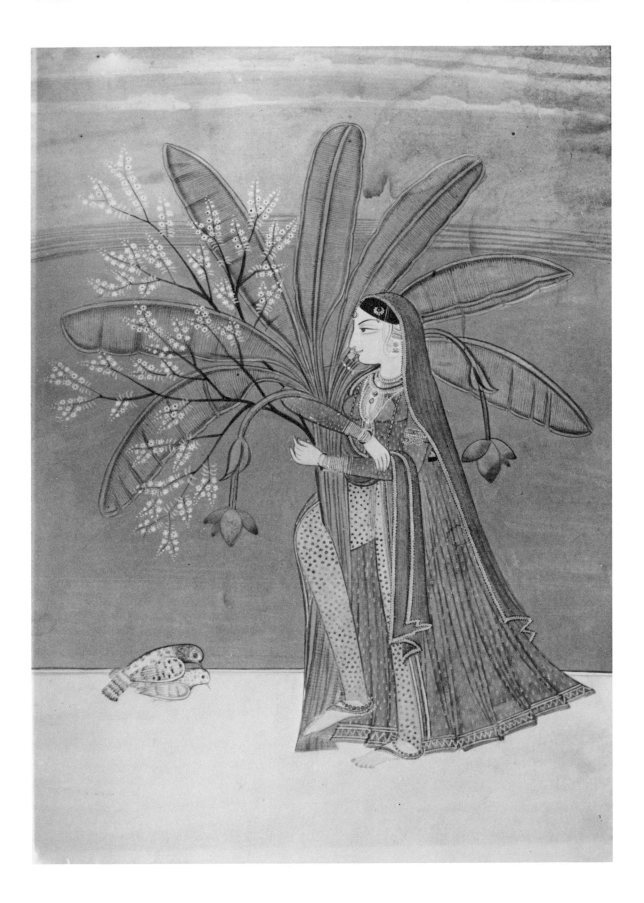

HINDUR (NALAGARH)

HINDUR (NALAGARH), C. 1830

27. *Rejoicings at the Birth of Krishna*

From a *Bhagavata Purana* series
9 × 13 in.

Like its neighbor Baghal (Arki), the state of Hindur was too close to the stony Sewalik Hills and the Punjab Plains to develop any strongly independent style of local painting. Under Raja Ram Saran Singh (1788–1848), it allied itself to Kangra and with Kangra aid relieved Kahlur of part of its territory. It also sided with Kangra against the Gurkhas when they swept down from Garhwal in 1805.

The present picture is an example of Hindur painting under Kangra influence. A cowherd and a crowd of cow-girls queue in a courtyard to offer presents to Jasoda and the baby Krishna while a small group of musicians play blaring trumpets and thunder away on drums. Two cow-herds, larger than life, plod across the dessicated hills. By no standards a great picture, it illustrates the kind of style which a hybrid environment—neither wholly Hill nor wholly Plains—could produce when the great traditions of Pahari painting were collapsing.

Publ.: Mildred Archer, *Indian Paintings from Court, Town and Village* (1970), pl. 29.

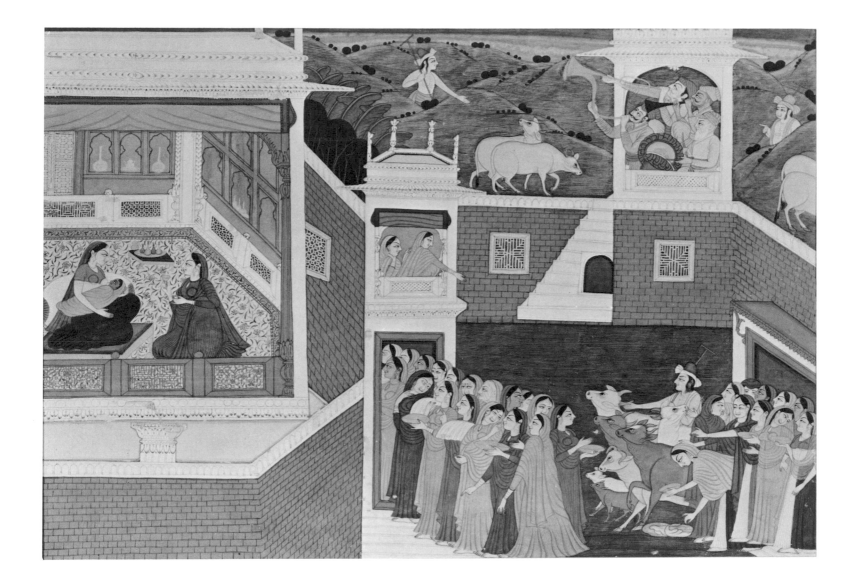

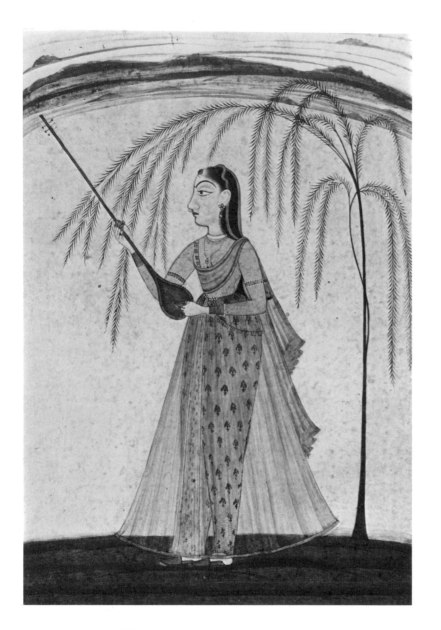

JAMMU, C. 1740

28. *A Singing Girl with Tambura*

$6^1/_4 \times 4$ in.

As premier state of the western hills for much of the eighteenth century, Jammu, it might be thought, would produce one of the greatest styles of Pahari painting. Apart, however, from a group of portraits celebrating with genius the life and dreams of a particular patron, Balwant Singh, the mainstream of Jammu painting favored a style of statuesque portraiture, noteworthy for its lack of animation and its muted colors. Rulers of neighboring states subordinate to Jammu were sometimes portrayed in female company, but in general there was a striking indifference to romance or passion.

The girl musician, who stands against a tepid yellow background, has the vapid staidness associated with many members of her profession. Her features are typical of the period and are a standard pictorial idiom for any or every woman. The frail willow tree with its achingly thin stem is an obvious parallel to the light and slender instrument with which she toys.

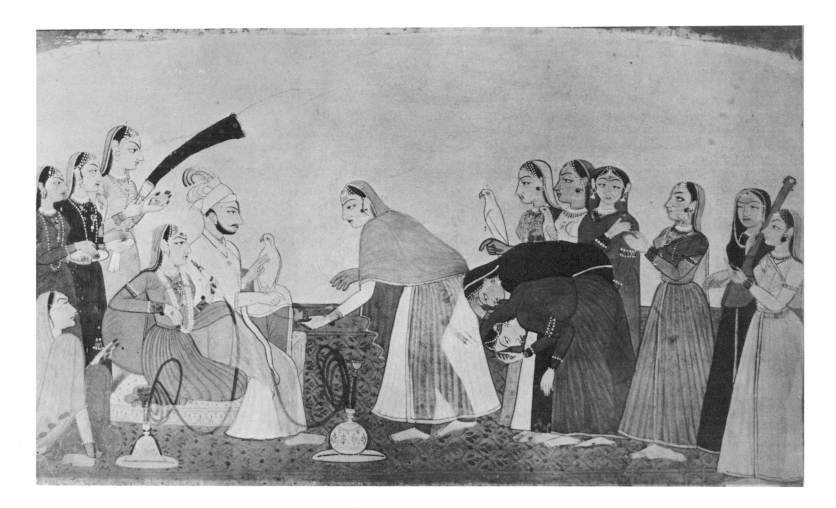

JAMMU, C. 1750

29. *The Presentation of the Hawks*

$6^{1}/_{4} \times 10^{1}/_{2}$ in.

This picture is similar in style to the preceding picture but notable for its far sunnier yellow background, a general preponderance of pale green and mauve, and for the extraordinary concourse of women surrounding the only man present, Raja Jit Pal (1736–1757) of Basohli. Four kinds of women can be distinguished—Jit Pal's principal rani seated beside him, ladies of the palace standing in mauve, slate blue and dark green behind her, six singers and musicians, two of them bowing low as if concluding a performance, and three female falconers. Two of these hold hawks on their wrists while the third, leaning forward, has just presented her hawk to Raja Jit Pal. Hunting with hawks was a common pastime in the Punjab Hills and courtly ladies and palace beauties, as well as men, had their own favorite falcons.

Publ.: Archer, *Indian Paintings from the Punjab Hills* (1973), Jammu no. 23.

51

JAMMU, C. 1785–1790

30. *The Encounter in the Cave*

From a *Bhagavata Purana* series
$10^1/_4 \times 14^3/_4$ in.

Like the light heavyweight world champion boxer John Conteh, who is reported to combine charm and gentleness in private life with savagery in the ring, Krishna, the arch lover of women, becomes a different person when confronted with enemies and demons.

In this picture his brisk killing of the tyrant king Kansa is matched by a lively struggle with Jambavan, the bear ruler who centuries earlier had aided Rama in his war against Ravana. Jambavan has killed the lion which had purloined a jewel, and Krishna is determined to recover it. As he hurls himself on Jambavan, the bear withstands his furious grapplings. Then, of a sudden, realizing that he is in fact fighting Krishna, he stops and begs forgiveness. He returns the jewel and offers Krishna his baby daughter, Jambavati, as a bride. While the fight rages at one end of the cave, Jambavan's queen, seated at the further end, lulls the child to sleep on a swinging cradle. The cave is set in a mass of humped and curving crags whose swirling disarray parallels the rough and tumble of the wrestling match. The face of Jambavan's consort has a serene beauty foreign to women in earlier Jammu painting and is a product in Jammu of styles already established at Guler and Kangra.

Publ.: Mildred Archer, *Indian Paintings from Court, Town and Village* (1970), pl. 28.

52

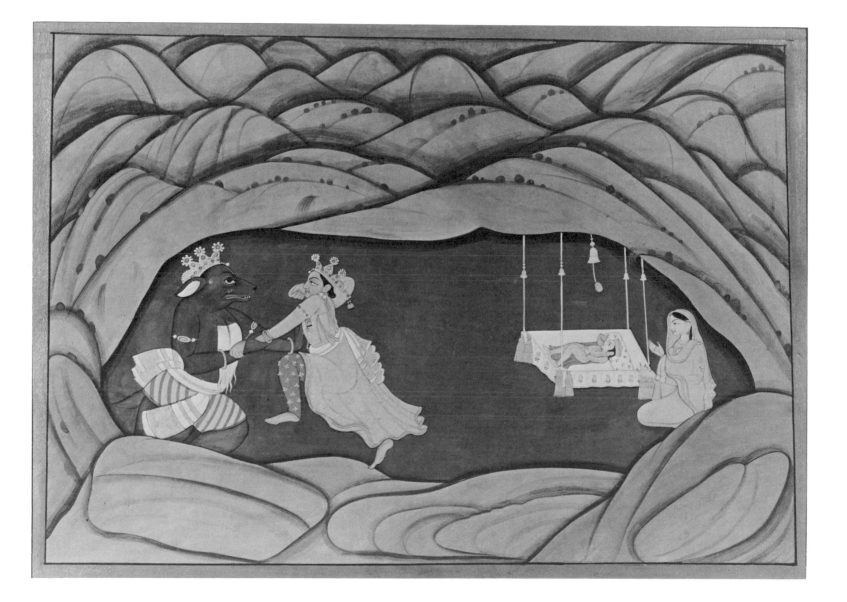

JAMMU, C. 1750–1755
By Nainsukh

31. *Raja Balwant Singh (1724–1763) of Jammu at a Window*

6 × 5 1/4 in.

In striking contrast to other portraiture in the Punjab Hills, Nainsukh's portraits of the Jammu prince Balwant Singh, fourth and youngest brother of Raja Ranjit Dev (1735–1781) of Jammu, bring him vividly to life as a quaint but strangely loveable eccentric. Endowed with an annual income of 40,000 rupees, he delighted to parade his feudal grandeur and to appear moving in stately processions through the countryside, surrounded by his minions and even indulging in the imperial sport of lion hunting. In such pictures, he has a regal splendor and his face is grave, authoritative and composed. At other times, he, so to speak, "undresses." He is then the master of a country household, at one with his loyal retainers, the proud possessor of private singing-girls and musicians, a connoisseur of music and himself a songwriter. The regal airs vanish and Nainsukh catches him at his toilet, superintending the building of a house, creeping up behind a cow to shoot a sitting duck, releasing his favorite falcon, or even stripped to the waist, penning a composition in camp. Each of his two sides is subtly recorded, and the portraits are annotated, sometimes by himself in a straggling *takri* hand of appalling illegibility, and sometimes to his dictation by a secretary whose neat script matches Nainsukh's deftness. Again and again, the inscriptions include the first line of one of his own love songs and in two cases involve a pun or a play on words. He clearly had an abounding sense of humor and may well have egged Nainsukh on to sketch him in ridiculous situations, gravely occupied with the totally absurd.

The present drawing belongs in essence to a group of sketches made in the years 1750 and 1751 when Balwant Singh was toying with the idea of constructing a mansion on his country estate of Saruin. He may have found it difficult to make up his mind and in these drawings Nainsukh appears to give him a choice of possible buildings and to suggest what it might feel like to live in them. In one drawing he shows Balwant Singh sitting smoking at a ground-floor window, the great mansion towering above him and the window shutters flung wide open, as in the present sketch. The building was probably completed in 1751, and when I strolled round its ruins in 1970, I could still see traces of the mansion as Nainsukh had envisaged it and also the ridge of rising rock on which it was ultimately built. This ridge also appears in two of Nainsukh's sketches. In the present drawing, Balwant Singh is shown close-up, his face lost in thought, and one can only guess whether it was drawn after the building had been completed and he was living in it, or whether he was still anxiously weighing up the pros and cons of rival plans.[1]

1. For a full discussion of these enigmatic portraits—as original and mysterious in their way as those of the Emperor Jahangir or of Ibraham Adil Shah II of Bijapur—see Archer, *Indian Paintings from the Punjab Hills* (1973), Jammu nos. 24–53.

Publ.: Mildred Archer, W. G. Archer and Sherman E. Lee, *Indian Miniatures from the Mildred and W. G. Archer Collection* (1963), pl. 49; Mildred Archer, "Indian Miniatures," *Art International* (1963), VII, no. 9, 20.

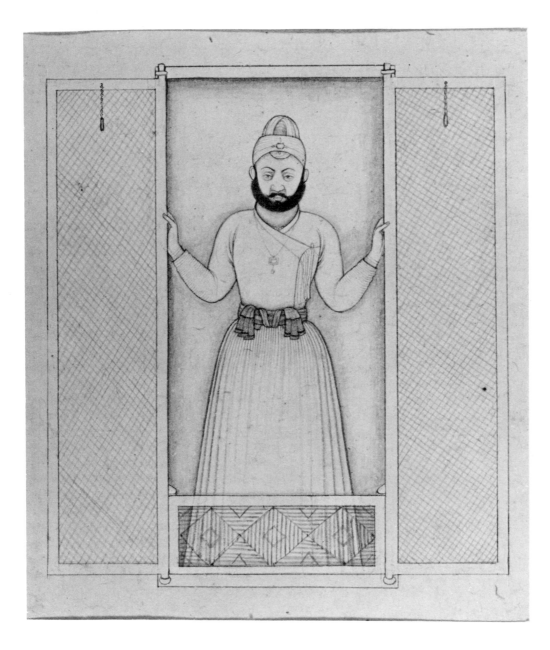

KAHLUR (BILASPUR)

KAHLUR (BILASPUR), C. 1670–1680

32. *A Messenger Is Dispatched*

$8^3/_4 \times 12$ in.

"The ride from Arki (Baghal) to Bilaspur (Kahlur)," wrote J. C. French,

is beautiful with the beauty of these hills, now rising to the high pine-forests and now dipping steeply into the little valleys. Over the mountain torrents are the little water-mills with sloping roofs. Nothing more ancient or primitive could be imagined. They seem part of a fairy-tale scene. At the top of every rise the line of snowy mountains which separate Kangra from Chamba comes into view. Just before Bilaspur the hills widen out and leave a great amphitheatre of open space. I came to it in the late afternoon. Under the setting sun the great valley was clothed in a rich blue haze, a scene of mellow loveliness.

When I myself visited Bilaspur in 1966, the amphitheatre, known locally as the Sandhu, had reappeared from the Sutlej river, by which it had been submerged on account of the building of the Bhakra dam. There had been poor rainfall the year before and as a consequence the level of water in the river had sunk, thus enabling one to take an evening stroll across the previously flooded valley. As we walked we could see still standing the foundations of the old town, as well as some of the walls of the nineteenth-century palace.

The present picture is from an unidentified series concerned in some way with the anxieties of a ruler. The scene is a garden laid out in rectangles with lushly flowering plants and bushes. The only seated person—a crowned figure in a red dress—is handing a rolled-up scroll or letter to a messenger. Other courtiers agitatedly discuss the situation.

The picture is of interest since, like a portrait of Raja Dip Chand (1650–1667) of Kahlur listening to girl-singers,[1] it represents an adjustment of early Aurangzeb-style Mughal painting to Hill conditions. Dip Chand had campaigned on behalf of Aurangzeb on the northwest frontier and must therefore have been acquainted with the imperial capital at Delhi. It is possible that a Mughal artist from Delhi settled at Bilaspur and thus established a local style. Typical of this style is the sensitive rendering of faces and the sprightly "Mughal" short-skirted dresses.

Besides Mughal painting, Rajput painting from Rajasthan and central India seems also to have been influential. The reduction of the figures, architecture and landscape to a single flat plane, the bold presentation of forms and the strongly geometric ordering of gardens, buildings and background all suggest an influence from these areas. Like the rulers and courtiers of Baghal (Arki), members of the Kahlur family hailed from the Chanderi region in central India and added a similar suffix "Chandla" or "Chandel" to their names.

Points of detail which appear in other pictures and thus contribute to the effect of an overall Bilaspur style include the deliberate dwindling or shortening of the lower limbs, occasional truncations of the figure, the detailed depiction of bricks in garden or palace walls, and a marked conjunction of the colors white, gray, orange-red, dark red, green and brown. In association with white and gray, the color orange-red leads to startling "shock" effects.

1. Archer, *Indian Paintings from the Punjab Hills* (1973), Kahlur no. 1.

56

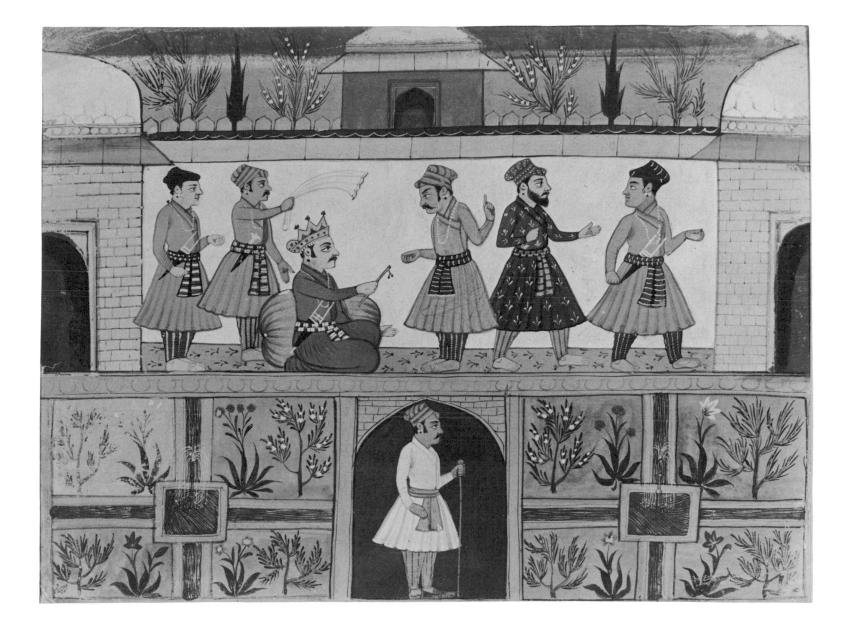

33. *A Portent*

$9 \times 11\frac{1}{2}$ in.

This picture is from the same unidentified series as 32, perhaps taking the intriguing narrative a stage further. The King is seated with seven courtiers in the same kind of bleakly bare setting. The background is a rich chocolate brown and above the assembly is a simple white turret and a tilting cypress tree. An air of expectancy pervades the gathering, and it is as if a moment of crisis is about to be reached. To the right, a slim tree has put forth yellow flowers, a courtier in green dress is urgently calling the King's attention to it and the company has obtained what it was perhaps waiting for—a portent.

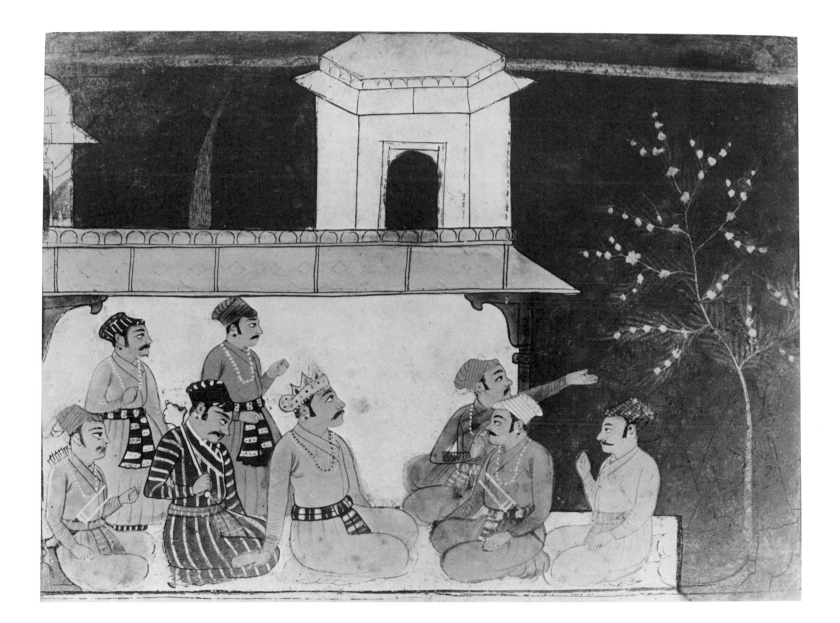

KAHLUR (BILASPUR), C. 1700

34. *Punyaki Ragini*

From a *Pahari Ragamala* series
$9 \times 6^{1}/_{2}$ in.

In this picture, a lady (a consort of Bhairava *Raga*) confronts a Brahmin mendicant who stands before her in a mauve dhoti holding out a begging bowl. From a white bag held behind her she has taken out coins and is dropping them with her right hand into the bowl. As she does so, she gazes keenly at the visitor who returns her gaze, eye meeting eye. From behind the lady, a maid, half-visible on account of a latticed door or screen, watches the encounter.

With its sage green background, stark simplicity of structure and flair for geometry (seen in the blackish brown railings, the brown rectangular bricks edged with white and the series of rectangles involved in the pavilion and latticed door), the picture has much in common with previous Bilaspur painting. Mauve is again prominent but new details are also present. The floral scrolls appear-

ing at the base and on the roof are vivid reminders of the flowering plants and shrubs in 32 and the dark red of the lady's blouse and the maid's skirt imbue the scene with sultry richness.

Although the bestowal of a gift to a mendicant is common to all versions of Punyaki *Ragini*, the gift varies oddly from example to example. In a slightly earlier Bilaspur series of 1680–1690, the gift was a piece of jewelry. In a later series of 1740–1750 it became a spurt of liquid from a golden spray, and in a Kangra picture of about 1785 it is even transformed into a stalk of barley. None of these pictures is accompanied by verses but since there is often a marked disparity between *Ragamala* verses and *Ragamala* pictures, it is unlikely that verses would have thrown light on this strange assortment of gifts.

60

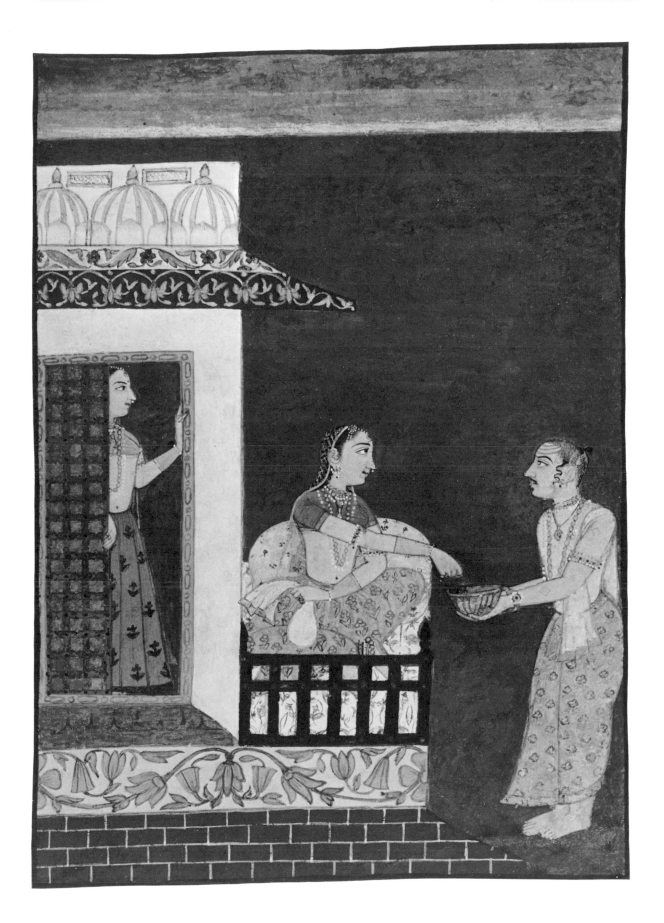

KAHLUR (BILASPUR), C. 1700

35. *Krishna's Horoscope Is Cast*

$7^3/_4 \times 10^1/_4$ in.

The baby Krishna has been successfully smuggled out of Mathura, and the time has now come for casting his horoscope in the household of his foster parents, Nanda and Jasoda. The family sits on a rug to the left, the pundits and astrologers on another rug to the right. Four bullocks, unyoked from the visitors' carriage, gaze with yearning intensity at the blue child. The asymmetrical rugs and the carriage yoke—all in hot orange-red—direct the eye to the small sacred fire burning briskly on the white veranda floor. In four wall-niches blue and white fruits are piled up, creating, as in a picture by Crivelli, a comforting atmosphere of fruitful prosperity. A gray wall, its bricks dimly outlined in white, provides a sober background to the solemn ceremony. With trees eagerly thrusting their branches towards the modest dwelling, the whole scene has something of the wondering mystery of an "Adoration of the Magi."

Publ.: Mildred Archer and W. G. Archer, *Romance and Poetry in Indian Painting* (1965), pl. 33.

62

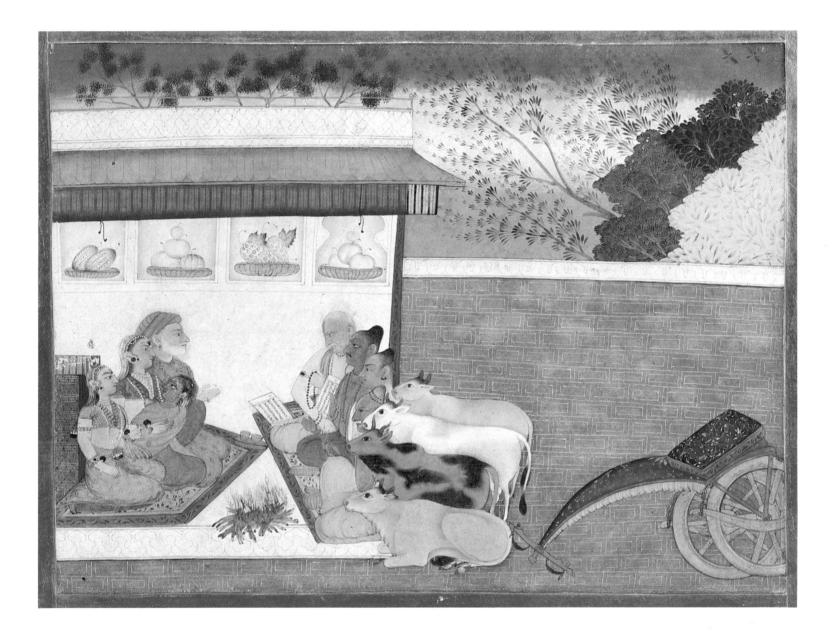

KAHLUR (BILASPUR), C. 1750

36. *Sandehi Ragini*

From a *Pahari Ragamala* series
$8\,^1/_4 \times 6\,^1/_4$ in.

Here is a scene of tender departure. A warrior with a black shield dangling from his shoulder and an orange-red scabbard projecting from his further hip is holding hands with a lady, who appears unable or unwilling to let him go. No mere gallant, he is more probably a husband "off to the wars"—though the attitude of devoted attachment might also spring from an extramarital affair. On the extreme right, a maid, dwarfed out of all natural proportions, peeps fearfully out from behind a flapping curtain. The prevailing mood—generated by the extreme pallor of all but one of the colors—is of wan despair verging on tearful sadness. It is, in fact, only the huge orange-red bolster—its color deftly echoed in the scabbard and turban of the lover-warrior—that strikes a more positive and confident note, hinting, as it does, at previous raptures and at the ardent encounters which will await the lover on his return.

Publ.: Mildred Archer, *Indian Paintings from Court, Town and Village* (1970), pl. 19.

64

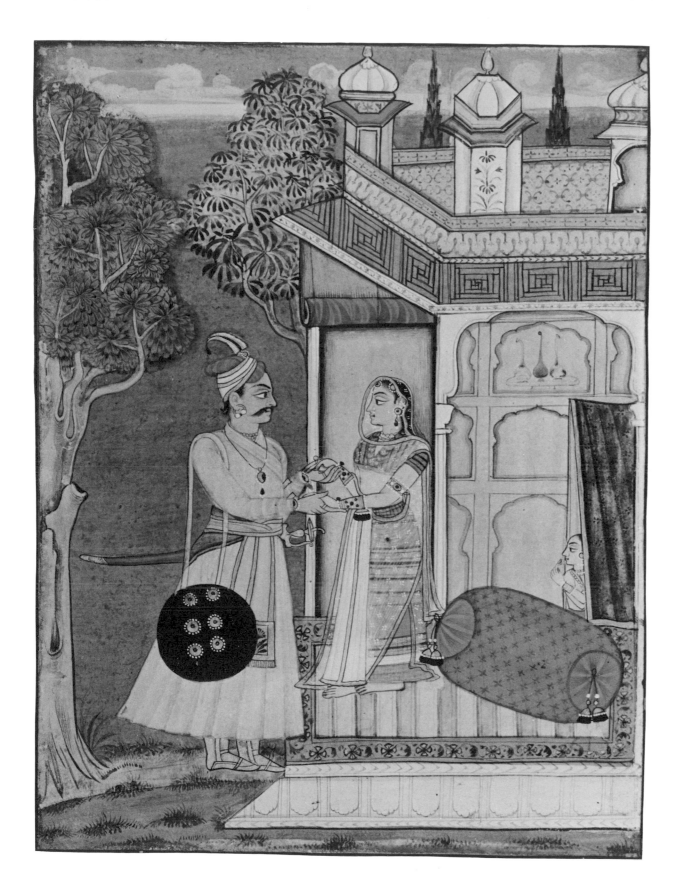

KAHLUR (BILASPUR), C. 1760

37. *Raja Govardhan Chand (1741–1773)*
 of Guler Smoking
 $8^1/_4 \times 6^1/_2$ in.

This is a study of Govardhan Chand of Guler by a Kahlur painter, probably made from a Guler portrait of him when he was some ten years younger. It is noteworthy that smallpox scars are plainly visible on his face, and this would suggest either that he was known to have this disfigurement or that the painter may, at some time, have actually seen him. In other studies of him by Guler artists, these scars are tactfully omitted.

The portrait, with its pale gray background and plain dresses—white in the case of Govardhan Chand and the standing courtier, sage green in the case of the servant with the fan—is enlivened by orange-red pillows and bolster, the color so strongly favored in almost all Kahlur painting and almost always carrying with it an ulterior meaning. Who, for example, looking at this simple, slightly overanxious face, would suppose that here was an iron administrator, a terror to the Bhatelar Rajputs of his State—so much so that they had to prick his ears and nose before they could believe that he was truly dead?

Who also would guess that he was so keen a horseman that at Guler he was portrayed riding his favorite charger in full armor and that he even went to war with a Mughal Viceroy rather than surrender this loved animal? Finally, who would think that during his reign Guler painters had produced some of the loveliest interpretations of the female form in Pahari art? A diffused sensitivity to feminine charm, a liking for music and love-poetry, perhaps also the accidental presence in the Guler state of a body of enterprising artists might partly explain it. Yet of all these artists—their rivalries, movements and intrigues—how little do we really know! Some further explanation is needed. Could it, just possibly, have been his own worn face, so cruelly ravaged, that made him seek relief in pictures and in the process become so great a connoisseur and patron at such a crucial time?

Publ.: Mildred Archer, *Indian Paintings from Court, Town and Village* (1970), pl. 20.

66

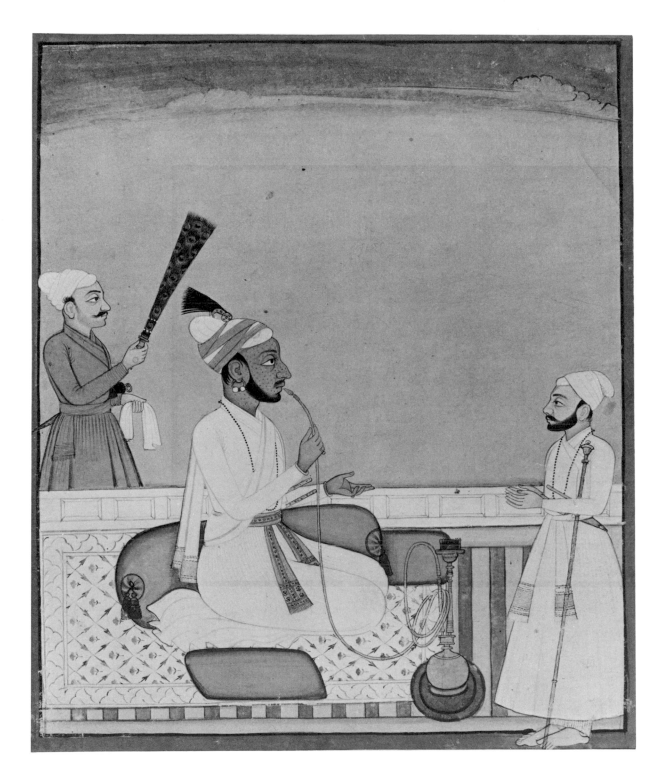

KAHLUR (BILASPUR), C. 1780

38. *Krishna's Flute*

$7^{3}/_{4} \times 10^{3}/_{4}$ in.

Of the tribal peoples of eastern India, the Santals are the most numerous, the most integrated and possibly the most resilient. "The ever-singing, ever flute-playing Santals" is how they were described by an early observer, and flute-playing was still one of their characteristics when I lived and worked among them in the years 1942 to 1946 as Deputy Commissioner of the Santal Parganas. Allusions to flute-playing constantly occur in their songs, the flute serving not only as an open invitation to romance but often as a symbol for a Santal boy himself.[1]

The same realization had led another observer, Dalton, to declare that "the peculiar emblem of the Santals should be the flute." Sensing also that certain Santal dances were the most vivid living representation of the sports of Krishna in Brindaban, he compared them to the circular dance of Krishna with Radha and the milkmaids.

We have in both the maidens decked with flowers and ornamented with tinkling bracelets, the young men with peacock's feathers, holding their hands and closely compressed, so that the breast of the girl touches the back of the man next to her, going round in a great circle, limbs all moving as if they belonged to one creature, feet falling in perfect cadence; the dancers in the ring singing responsive to the musicians in the centre, who, fluting, drumming and dancing too are the motive power of the whole, and form an axis of circular movement. Thus, as pivot for the dances, sometimes sported Krishna and his favourite companions, "making sweet melody with voices and flutes" but more frequently they took their places in the ring, each feeling the soft pressure of the two maidens in the great circling dance. We are told that Krishna when he thought the lovely light autumn propitious for the Rasa dance, commenced singing sweet low strains in various measures such as the Gopis loved, and they as soon as they heard the melody quitted their homes and joined him; just so, on a moonlight night, the Santal youth invite the Santal maidens.[2]

The present picture shows Radha vainly resisting the call of Krishna's flute. Garbed as a princess in flowing blue dress, she is explaining to her maids her dilemma. The setting is a palace, and through its various arches one discerns a great bed with twin pillows, a large bolster and long slim fan. The fan's color is orange-red and in conjunction with the red floor on which Radha stands and the orange floor immediately behind her, it provides a plain hint of possible developments. It is not only her aristocratic attire or pretended scruples, however, which hamper action. Below the balcony courses a river and this has first to be crossed before she can boldly join Krishna and his cowherd companions. These are equipped with cymbals, tambura and tamborine and, in conjunction with Krishna's flute, will admit of no refusal. In Bilaspur painting, subsidiary objects and figures were often scaled down, and here the cows are of such minor importance that they are shown as no larger than puppies.

1. W. G. Archer, *The Hill of Flutes: Life, Love and Poetry in Tribal India; A Portrait of the Santals* (1974).

2. E. T. Dalton, *A Descriptive Ethnology of Bengal* (1872), p. 215.

Publ.: Mildred Archer and W. G. Archer, *Romance and Poetry in Indian Painting* (1965), pl. 35; Archer, *Indian Paintings from the Punjab Hills* (1973), Kahlur (Bilaspur) no. 44.

68

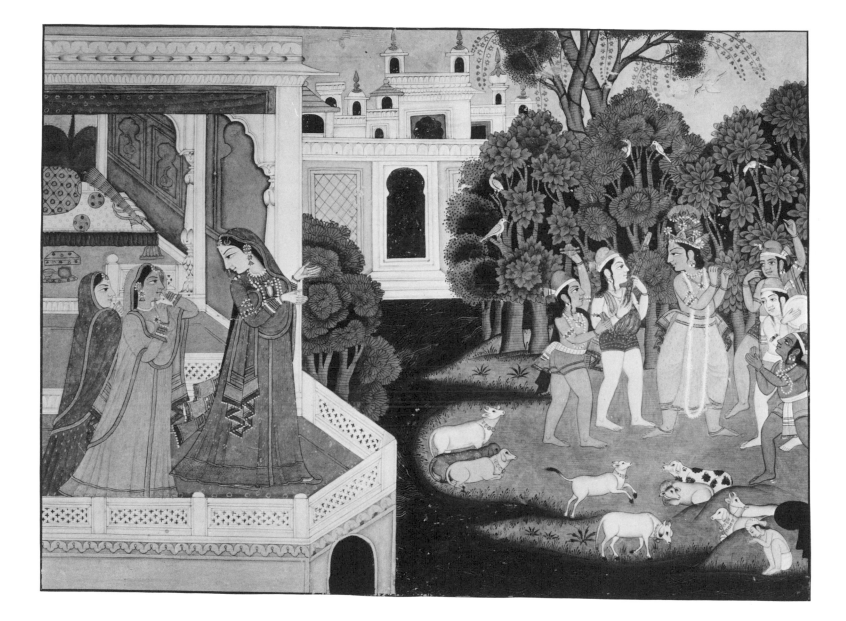

KANGRA

39. *The Great Snake*

11 × 8 in.

During the reign of Raja Sansar Chand (1775–1823) of Kangra, the lyrical naturalism which had first developed at Guler achieved fresh heights of passionate expression. Kangra was Guler's large and powerful neighbor, and although the great castle at Kangra remained first in Mughal, and later in Sikh, hands until 1786, the Kangra rulers had steadily regained their territory in the valley of the river Beas on the eastern side of the state. Their principal courts were at Sujanpur, Alampur and Nadaun. Ardent Vaishnavism had reached Kangra at the extreme end of the seventeenth century when Raja Alam Chand (1697–1700) had built a small Vishnu temple at Alampur. It had then undergone partial eclipse but in the closing years of Raja Ghamand Chand (1761–1774), his son, Tegh Chand, may have given it new impetus. Tegh Chand reigned for only one year (1774) but when his own son, Sansar Chand, succeeded him at the age of only ten years, it was clear that a determined and precocious boy had come to power. A firm adherent of Shiva and the Devi, he was already a devotee of Vishnu and of his special incarnation, Krishna. As explained by Dowson, "Vishnu's seventh and eighth incarnations, Rama and Krishna, are honoured as great mortal heroes and receive worship as great gods. Krishna is more especially looked upon as a full manifestation of Vishnu and as one with Vishnu himself."[1] It was on Vishnu in the form of Krishna that Sansar Chand lavished a lifetime's devotion.

Besides his adherence to religion, Sansar Chand had a great "fondness for drawing" and, with the sole exception of Balwant Singh of Jammu, he is the only Pahari ruler to be actually portrayed seated with courtiers, holding "picture sessions," scrutinizing miniatures and passing them round from hand to hand.[2]

The present picture shows Vishnu, four-armed and reclining in a coil of the great multi-headed snake Sesha Naga, who supports him on the waters of eternity. Opposite him sits his consort, Lakshmi, tenderly massaging his feet. Like Rama and Krishna, Vishnu is shown with a blue or dark mauve skin. He also wears the peacock-feathered crown associated with Krishna (though not with Rama). Vishnu's special connection with Krishna is thus implied. It is Sesha Naga, however, that truly dominates the scene. Here is the very essence of clammy snakehood, succulent, soft and in its corpselike pallor possessing a slimy majesty which takes it out of this world. Its crowding heads press forward like a shoal of fish and, despite its mood of docile unconcern, it emits an eerie chill. The "multitudinous seas" around it are evoked by a waste of silvery gray, the uneven washes suggesting the movement of the ocean. The oval shape, with its resemblance to the "cosmic egg," reinforces still further the sense of primeval mystery.

Although the extreme elongation of Vishnu's form might at first sight suggest a Guler provenance, the decorated spandrels in the four corners are wholly typical of Kangra painting. The brightness of coloring, seen in the figures of Vishnu and Lakshmi, is also a Kangra characteristic easily recognizable in the pictures that follow.

1. J. Dowson, *A Classical Dictionary of Hindu Mythology* (1957), p. 361.
2. Archer, *Indian Paintings from the Punjab Hills* (1973), Kangra nos. 10, 16.

Publ.: Mildred Archer and W. G. Archer, *Romance and Poetry in Indian Painting* (1965), pl. 47.

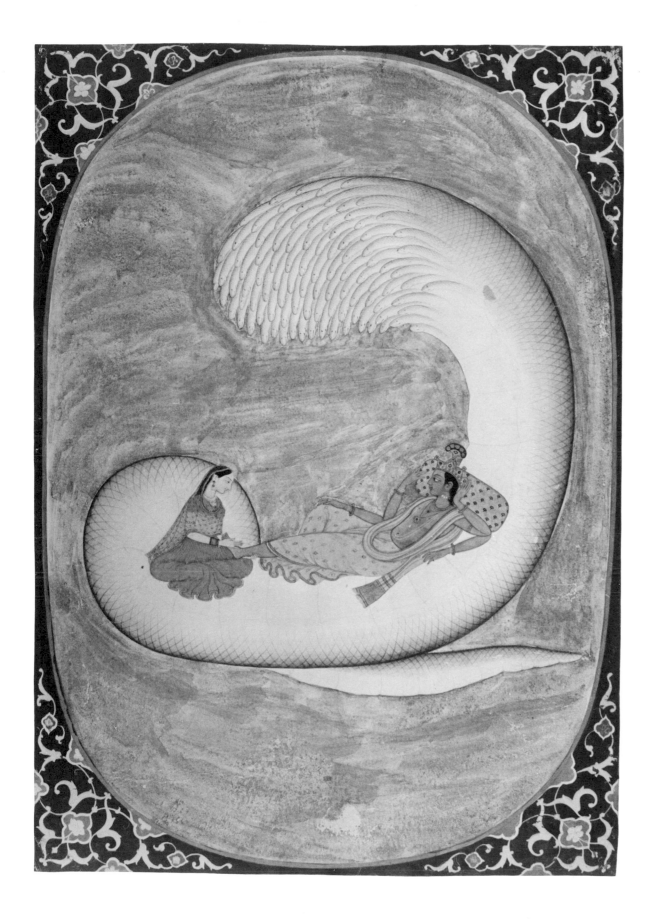

40. *Rama, Sita and Lakshmana at the Hermitage*

From a *Ramayana* series, *part 2, Ayodhya kanda*
8 × 12 in.

The *Ramayana* series from which this and the following two pictures are taken may well have been begun at the instance of Sansar Chand's mother or of the family priest. In style and date, it joins two other great Kangra sets—the "first" *Bhagavata Purana* and the "first" *Gita Govinda*. All three could have been commissioned in anticipation of Sansar Chand's marriage in 1781.

Although the event illustrated in the picture is supposed to have occurred at Prayaga (present-day Allahabad), the local Kangra landscape in the neighborhood of Sujanpur and Alampur is its glamorous setting. Rama has been sentenced to fourteen years' exile in the forests by his father, Dasaratha, as a result of machinations by Kakaiyi, his stepmother. He has taken a loving farewell and, accompanied by his wife, Sita, and brother, Lakshmana, has reached the hermitage of a great sage, the Maharishi Bharadwaja. The sage recognizes his exalted visitor, places on his neck a long garland of white and red flowers and urges him to make the hermitage his permanent place of residence. Rama excuses himself on the ground that it adjoins the sacred confluence of the Ganges and Jumna, a famous place of pilgrimage and that he must move deeper into the forests in order to obtain "a lonely place where Sita can live in happiness." Bharadwaja takes the point and advises the party to plunge ten miles deeper into the forest where they will find the mountain Chittrakuta, the abode of more hermits and far removed from ordinary men.

In the picture, the party has just arrived and Bharadwaja's disciples are pressing on them every available kind of fruit—pomegranates, mangoes, apples, melons, grapes and plantains. The settlement is seething with excitement as one disciple after another rushes to honor Rama with an offering. In the mid-center, a young hermit has climbed a tree, the better to view Rama and adore him. Large trees dominate the center and a rushing stream with boulders, a cave with an ascetic, and a great leaning hill give on to a vista of sloping uplands dotted with hermits' huts. A commanding rhythm welds the landscape into a single poetic whole—the red of Sita's veil providing a dazzling center.

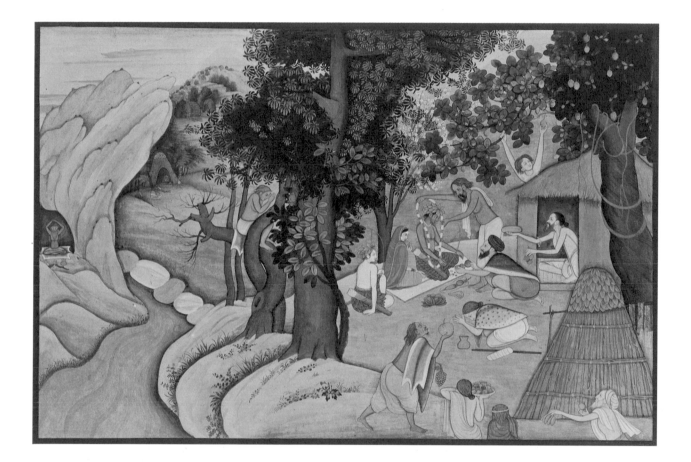

KANGRA, C. 1775–1780

41. *The Pursuing Party Arrives*

From a *Ramayana* series, *part 2, Ayodhya kanda*
$8 \times 12\,^1/_4$ in.

This is a sequel to the previous picture. Rama's father, Dasaratha, has died. Bharata, his son, has been proposed as king but from loyalty to Rama has set out to discover the latter's whereabouts, bring him back and place him on the throne. Following Rama's route, he and his brother Shatrughna, accompanied by two of Dasaratha's consorts, and a vast army reach the neighborhood of Prayaga. Bharata goes ahead with his brother to meet the sage Bharadwaja. He explains his mission, obtains the sage's approval and is then invited to bring up the entire army to the hermitage. Here the sage arranges for their shelter, food, drink and entertainment. Heavenly dancing girls and musicians are conjured down from the skies, food and wine are liberally supplied and a vast banquet and orgy ensue. In the morning the army goes surging on its way.

In the picture, no attempt is made to record the encampment in all its complex variety. Instead, a sample of the night's activities is given. The wildness of the forest, its peace and loneliness are suggested by two bare hills which rise gauntly in the foreground and impose their massive forms on the hermitage. In the foreground to the right, Bharata and his brother review the situation with Bharadwaja. Behind them, in a grove of trees, their followers are being fed and humble domestic tasks such as watering the cattle are being performed. To the left are tents with screens and three palanquins are parked beside them. In the distance, higher up a hill, is yet another tented enclosure where tiny dancing girls and musicians are entertaining an assembly of even tinier warriors.

As in the previous picture, it is the masterly composition that most impresses. By means of firmly binding lines and large shapes, the multitude of midget personages are contained within the picture and the artist's skill in endowing each of them with verve and animation becomes the more astounding. The landscape is again redolent of the Beas valley in the neighborhood of Sujanpur, the line of hills on the extreme left exactly corresponding to the Sujanpur countryside.

74

42. *An Ogre Obtains Release*

From a *Ramayana* series, *part 3, Aranya kanda*
$8 \times 12^{1}/_{4}$ in.

Since Bharata's departure, much has happened. Sita has been abducted by Ravana, demon king of Sri Lanka (Ceylon), and Rama and Lakshmana, clad in leaf-skirts and leaf-hats, and armed with swords, bows and arrows, are now engaged on a seemingly hopeless quest, combing the great forests for news or traces of the vanished bride. As they enter the Krauncha forest, they encounter the ogre Kabandha "of vast proportions, his mouth in his belly, covered with bristling hairs, his complexion that of a dark cloud." "His single eye, furnished with yellow lids, opening in his breast was strange and hideous." His teeth were enormous and his arms so vast that he could catch and devour creatures within a distance of four miles. Kabandha threatens to eat Rama and Lakshmana, whereupon the brothers "choosing a favourable moment as if in sport cut off his two arms at the shoulders, Rama cutting the right and Lakshmana with a vigorous stroke of his sword, the left." Kabandha enquires who they are and on learning their identities replies that he was once a handsome and powerful man who was changed to a demon by a sage. The sage had explained that only when Rama had cremated him in the lonely forest, having cut off both his arms, would he regain his former self. He begs to be cremated. Rama and Lakshmana agree, he is duly burnt on a funeral pyre, regains his previous shape and ascends in an aerial chariot. He then tells Rama and Lakshmana where to go in order to find Sita and urges them to ally themselves with the monkey leader, Sugriva.[1]

In the picture, liberties are taken as in 41. The ogre, while remaining fearsomely large and strong, is substantially reduced. He is given two eyes, not one, the more to emphasize his baleful glare, and his arms are truncated not at the shoulders but at the elbows. The final outcome is indicated in a meadow to the right. The scene, though intentionally horrific, is purged of shock or nausea by two factors—the ogre's slumping complacency as if he has already been anesthetized and the prancing ease with which the brothers wield their swords. Bows, limbs and weapons blend in a triumphal dance and even the ogre's gaping wounds contribute, with their neat red, a flicker of glory.[2]

1. H. P. Shastri, *The Ramayana of Valmiki* (1957), II, 145–155.
2. For an interpretation of the same incident by a Kulu artist, see Archer, *Indian Paintings from the Punjab Hills* (1973), Kulu no. 5(i).

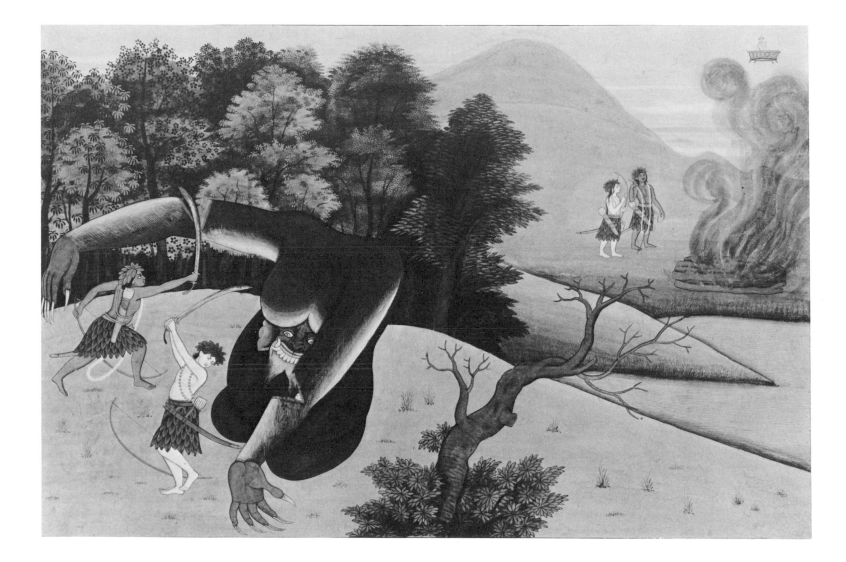

KANGRA, C. 1790

43. *The Spring Festival of Holi*

$8^3/_4 \times 6$ in.

Although reverence for Rama remained an essential part of Kangra court religion, it was the cult of Radha and Krishna that seems to have aroused Sansar Chand's greatest enthusiasm. Apart from founding the Murli Manohar temple in Sujanpur, with a spacious courtyard designed for Krishna worship, he made land grants "out of devotion to Lord Krishna" and regularly observed the annual Janmashtami festival (or "Birthday of Krishna"). In 1820 when the British traveler Moorcroft visited him at his court of Alampur, he noted that Sansar Chand spent his evenings watching dances at which the performers sang songs "generally reciting the adventures of Krishna and the gopees." Sansar Chand had also amassed an "immense" collection of drawings in which paintings of Krishna formed a major part.

In this picture, Krishna and the cowherds are doing battle with Radha and the cowgirls in the spring festival of Holi. Each party is syringing the other with yellow-colored water and throwing handfuls of red powder in return. The festival is proceeding with the spirited smoothness of a ballet and the gaiety of a joyous romp.

In the distance are three groups of midget figures, some of them busily drumming or playing the flute.

In palette, the picture exemplifies the greater warmth of color that distinguishes painting at Kangra from painting at Guler. There is also a greater brio, a zest for quickly seized poses and a keener sense of life in action. Naturalism is exploited but never at the expense of rhythm or design. It is easy to see Sansar Chand's own vital enthusiasm in this heightening of the Guler style and its transformation from a cult of the pallid to a cult of the passionate.

In Indian folklore, the Holi festival is believed to be preeminently a festival of Krishna—the streams of red water supposedly mimicking the spurts of blood that issued from the cow demon, Vatsasura, killed by Krishna in Brindaban.

Publ.: O. C. Gangoly, "Dole Leela," *Rupam* (1921), II, no. 6, col. pl. p. 15; W. G. Archer, *Indian Miniatures* (1960), col. pl. 91; Sherman E. Lee, *Rajput Painting* (1963), pl. 83; Archer, *Indian Paintings from the Punjab Hills* (1973), Kangra no. 42; Archer, *Pahari Miniatures: A Concise History* (1975), col. pl. 43.

78

KANGRA, C. 1790

44. *Krishna and the Cowgirls*

$8^{3}/_{4} \times 5$ in.

Here is another example of early Kangra painting, sharing with 40–43 the same range of typical "Kangra" colors, sense of warmth and fluid naturalism. Although surrounded by other young married cowgirls, Krishna's eyes are fastened on Radha. He is far from indifferent, however, to her companions since, despite a left arm on Radha's shoulder, his right arm finds its way through the group to clasp the hand of a girl in an orange dress who stands to the rear. Yet a third girl rests her hand lightly on Krishna's shoulder. In contrast to the dashing revelry of 43, there is now a feeling of grave reverence. Two cows stand calmly by and a pair of cowherd boys await the final dispersal. The symbolic lotus leaves and flowers parallel Krishna and the girls, and the flowering creeper that winds around the tree trunk echoes their delicate embraces.

Publ.: W. G. Archer, *Kangra Painting* (1952), col. pl. 7; K. Khandalavala, *Pahari Miniature Painting* (1958), no. 134; Mildred Archer, W. G. Archer and Sherman E. Lee, *Indian Miniatures* (1963), col. cover; Archer, *Indian Paintings from the Punjab Hills* (1973), Kangra no. 43.

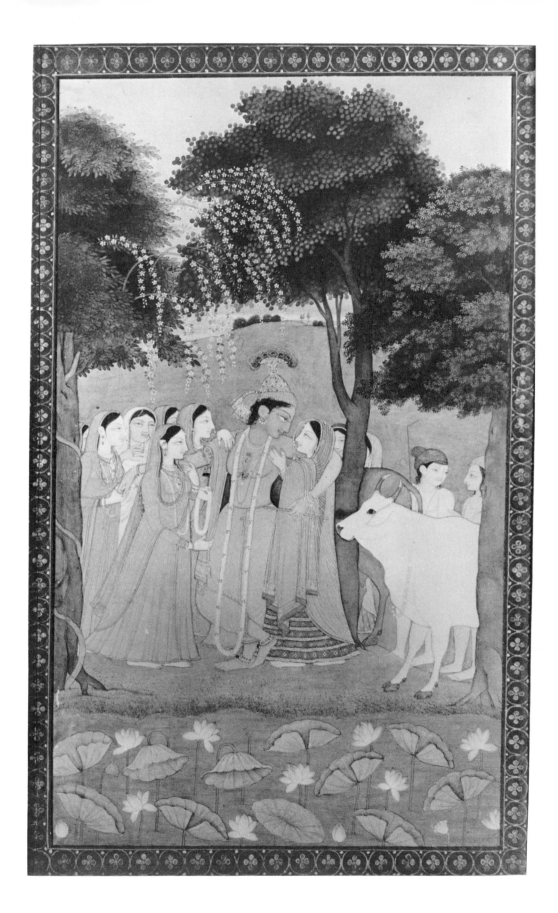

KANGRA, C. 1810

45. *The Lonely Lady*

8½×6 in.

Like 24, a lady, deserted by her lover, has discarded her jewels after vainly waiting. She has shed her dress, and apart from a pale red veil, which barely swathes her thighs, she is completely nude. Her hands are clasped above her head in desperation, and her long black hair caresses her back as if to console her body with substitute kisses. As in 21, a great bed dominates the scene and the plethora of spouted vessels, bowls, lamp shades, columns and oval medallions, all in intimate conjunction, reminds one of Lautréamont's lines—"Beautiful as the chance encounter of an umbrella and a sewing machine on a dissecting table"—where the umbrella is the lover, the sewing machine the woman and the table is the bed. Less ardent than 21 and with far greater detail than 24, the picture illustrates how painters at Kangra anatomized "women in love," stressed their physical charms and, by the intentional omission of friends, companions and indeed of all the inhabitants of a little town, conveyed a sense of total desolation.

Publ.: Mildred Archer, "Indian Miniatures," *Art International* (1963), VII, no. 9, 23: W. G. Archer and Deben Bhattacharya, *Love Songs of Vidyapati* (1963), pl. 31 (detail); Mildred Archer and W. G. Archer, *Romance and Poetry in Indian Painting* (1963), pl. 60.

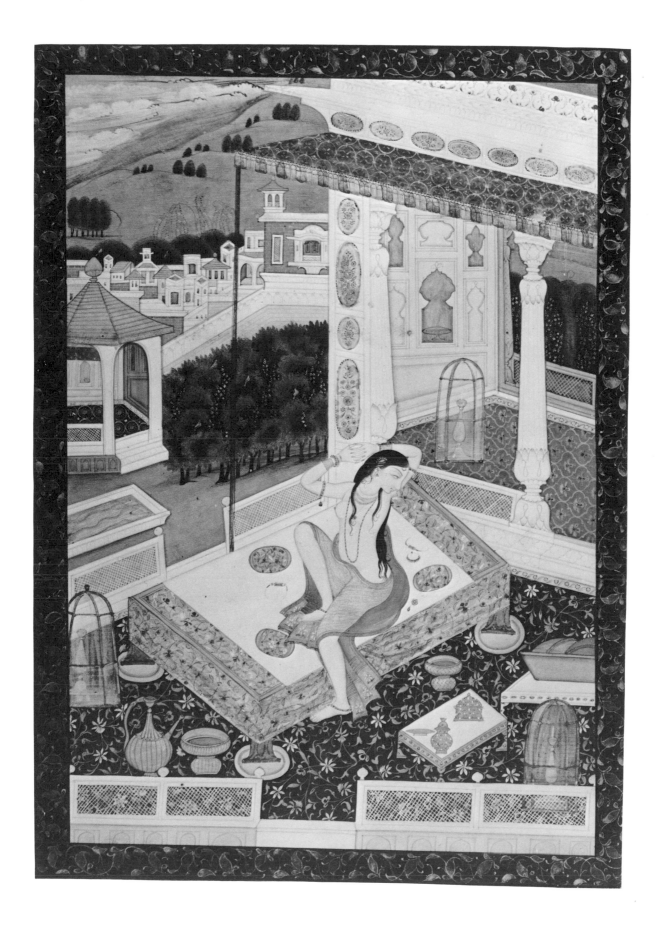

46. *Radha's Toilet*

7 1/4 × 5 in.

Radha, as sinuously depicted as the lonely lady of 45, squats on a wooden bathing platform, grasping her shoulders and lost in reverie. A maid approaches with towel and dish while behind her a second maid screens her with a green cloth. From a balcony, Krishna, with the pale mauve skin typical of late Kangra painting, gently signs to the maid not to betray his voyeur-like presence. For the moment, Radha is too absorbed in passionate thoughts to take off her clothes—the huge bunch of pink roses, soaring from the small vase, symbolizing her mounting frenzy. When, at last, she steps out of her clothes and begins to bathe, Krishna will view, unseen, the physical charms which have made her his supreme love.

Although "late" in style and coloring, the picture retains the delight in feminine grace which from Guler antecedents reached a climax in Kangra painting.

84

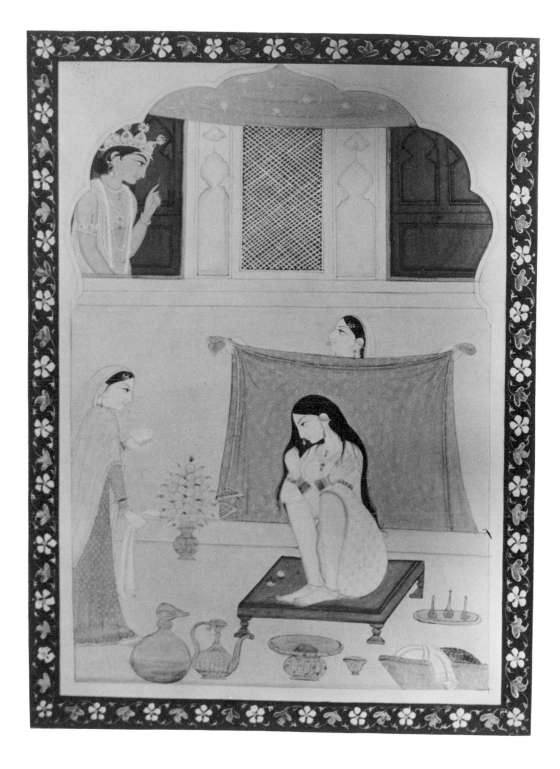

KULU

KULU, C. 1690–1700

47. *The Wedding Invitation*

From a *Ramayana* series, *part 1, Bala Kanda*
$8 \times 11^{3}/_{4}$ in.

In contrast to Kangra where painting reflected the mellow countryside of the Beas valley and its warm benign climate, Kulu, a large state deep in the Himalayas, produced a type of painting which paralleled the tormented character of its weird and harsh scenery. Lying north of Mandi and some fifty miles east of Kangra, it stretched for eighty miles among steep and icy mountains, broken only by occasional fertile valleys. Its queer and ghostly character was enhanced by the appearance of the local people, many of whom had thick necks and jowls due in part to the prevalence of goiter.

In about 1660, Raja Jagat Singh (1637–1672), a senior descendant from the same ancestral family as the Basohli rulers, brought an image of Raghunath (Rama) from Ayodhya in Oudh. He established it in the Kulu capital and formally conveyed the realm to the god. From then onwards, the Kulu rajas served as vice-regents of Raghunath and ruled the state in his name. Under Raja Man Singh (1688–1719), Kulu reached the zenith of its power, and this could well have prompted lavish thanksgivings to Raghunath, and the preparation, among other things, of a richly illustrated *Ramayana*. Until 1690, there is no evidence that Kulu had any painting, but the development at Basohli of a style of bold magnificence, coupled with the intimate relations existing between the two states, may have led Raja Kirpal Pal (c. 1678–1693) of

Basohli to send painters to Kulu to execute this project. Raja Ajmer Chand (1692–1741) of Kahlur (Bilaspur), to whom the Kulu family was related by marriage, may also have cooperated. The result was a large *Ramayana* series, heavily dependent for many of its idioms on Basohli painting but with a weird, neurotic glamor, and with extremities of mannerist distortion quite un-Basohlilike in spirit. Its pages fall into four main styles, one of which is an adjustment to Kulu conditions of painting at Kahlur. The present picture and the next are examples of Style II, characterized by strangely beaked noses, flat, plain backgrounds, toppling turbans and straggling rhythm.[1]

In the picture, Raja Dasaratha, king of Ayodhya and father of Rama, learns of Rama's successful contest for the hand of Sita, daughter of Raja Janaka of Mithila. In an upper storey, ladies of the palace gossip about the marriage, while below, Dasaratha confers with his minister, Sumantra, before giving formal audience to Janaka's emissary. The gravity of the occasion, the stupefied amazement of the court at Rama's success, as also its sorrowful implications (seen in the drooping foliage of the trees) are vividly expressed in diagrammatic form.

1. For a detailed discussion of this *Ramayana* series, known as the "Shangri" *Ramayana*, from Shangri, its place of provenance, see Archer, *Indian Paintings from the Punjab Hills* (1973), Kulu nos. 1–5.

86

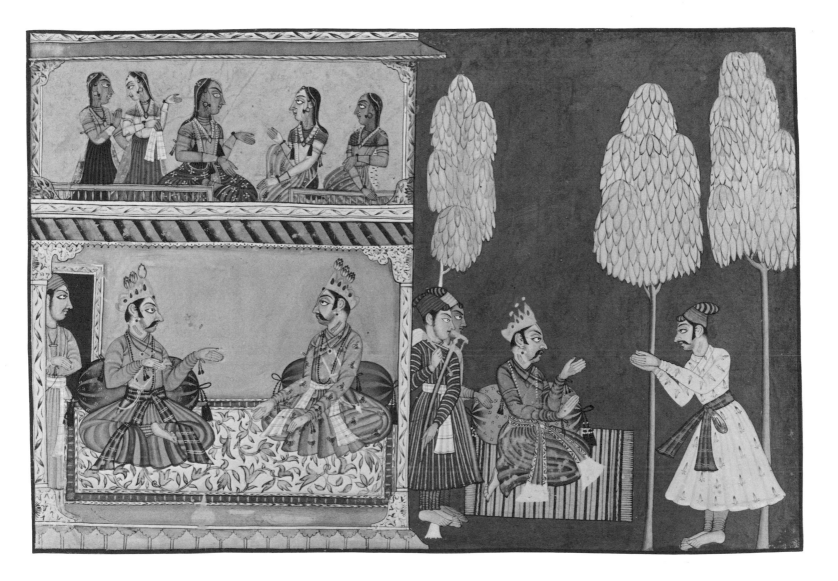

48. *The Wedding Party Returns*

From a *Ramayana* series, *part 1, Bala Kanda*
9 × 13 in. (with borders)

The ceremony at Raja Janaka's palace in Mithila has been completed and Rama and his brothers, accompanied by their father, Dasaratha, and by two of the family priests, are returning to Ayodhya. While Rama has been wedded to Sita, his brother Lakshmana has secured the hand of Sita's sister. Two other brothers have also been wedded to two of Janaka's nieces. In this way the two families have become intimately linked.

In the picture, Dasaratha and the two priests ride in chariots, Rama and his three brothers, each with a crown of lotus flowers, ride on horseback. In front of them goes a dazzling cavalcade, with trumpets blaring, drums beating and banners flying. Included are two small elephants the size of horses and a host of outriders and footmen clad in a rich variety of coats. As in some Basohli pictures, parts of the painting project into the margins—the picture space seemingly insufficient to contain the bursting ebullience of the packed crowd. With its golden yellow background, brilliant contrasts of color and jaunty, jazz-like rhythm, the picture has an air of frenzy which is the very opposite of the firmly disciplined Basohli manner.

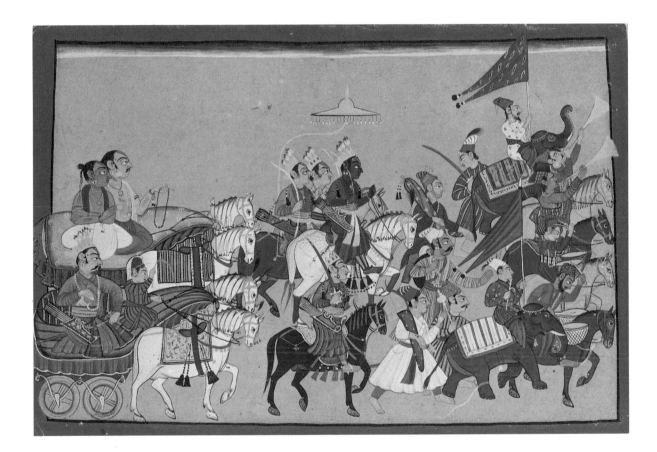

49. *A Wood Is Searched*

From a *Ramayana* series, *part 4, Kishkindha kanda*
$7 \times 11^{1}/_{4}$ in.
From the same series as 47 and 48 but in the "third"
 of four distinct styles

Following Sita's abduction by Ravana, a great quest for her has begun, and Rama's allies, the bears and monkeys, are combing every piece of forest. After days of unavailing search, their leader, Sugriva, sends a monkey party further south. Reaching a dense wood, they cautiously enter, peering intently ahead as if to smell out danger. The trees in the wood overlap each other in great clustering humps, their foliage alternating between mauve, yellow, green and orange. These strangely unreal shapes and colors have the weird magnificence which characterizes many later Kulu pictures. Sprouting in odd detachments from the ground, stark white tree trunks heighten the atmosphere of lush menace. Among the monkeys in the van is Hanuman, blue-skinned and wearing a yellow crown while, in the rear, comes Angada, nephew of Sugriva, also crowned.

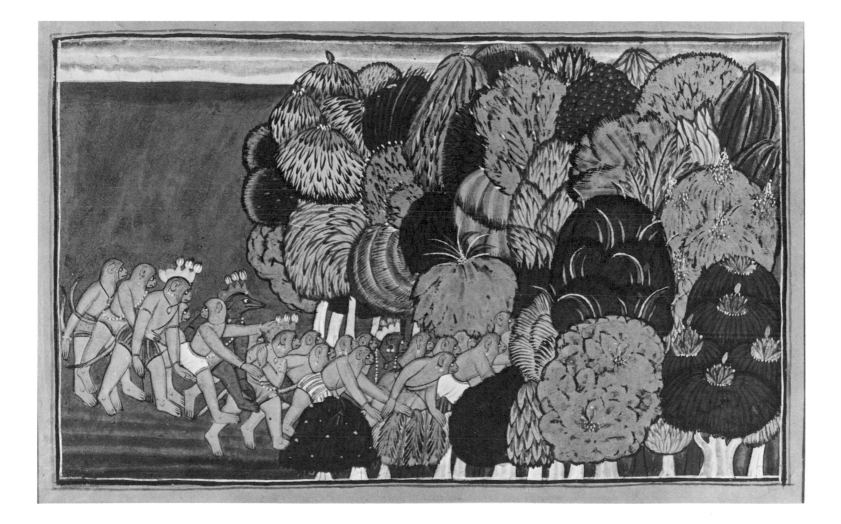

KULU, C. 1700–1710

50. *The Demon Is Surprised*

From a *Ramayana* series, *part 4, Kishkindha kanda*
$7 \times 11^{1}/_{4}$ in.

As the party proceeds, a demon suddenly breaks cover. He hurls himself at the leading monkey but is forced into a clearing. The whole monkey band then rushes forward to deliver a joint attack. Angada leads them and fells the demon with a punch on the jaw. The demon falls and expires.

In the picture, the swift charge is in progress, the monkeys are racing out of the wood, three monkeys with yellow crowns lead them, and the orange demon with sinister moustaches is in the act of falling. With its opposing clumps of fantastic trees, its lush exuberance, its celebration of nimble action and gay abandon, it joins 49 as an example of Style III. Basohli influences are present, but all are subdued by the jerky élan and impish audacity with which the scene is represented.

92

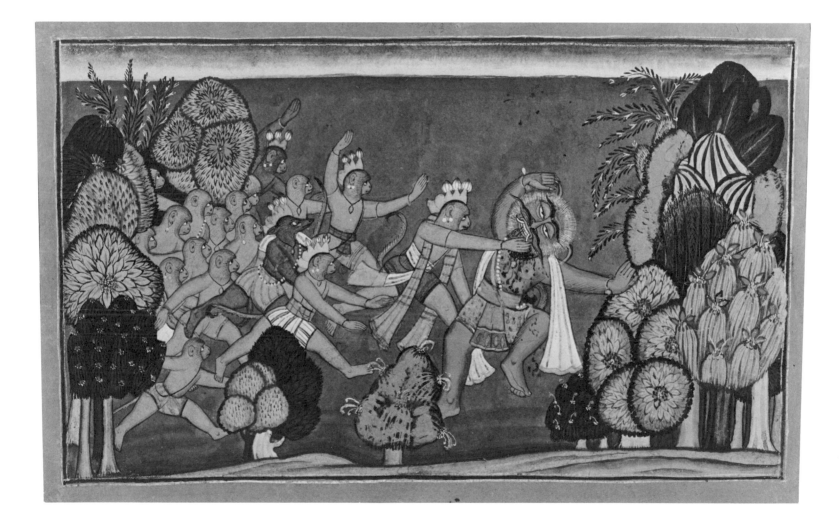

KULU, C. 1700–1710

51. *Rama Routs the Demon Horde*

From a *Ramayana* series, *part 3*, *Aranya kanda*
$7\,^1/_4 \times 11\,^1/_2$ in.
From the same series as 47–50 but in the "fourth"
of its four styles

Shurpanakha, an ogress who has attempted to seduce Lakshmana, has had her ears and nose cut off by him. She complains to her brother, the ogre Khara, who dispatches a horde of fourteen demons to slay Lakshmana, Rama and Sita. Rama elects to meet them armed only with a great bow. His arrows fall swiftly on them and the attack becomes a rout. As the arrows pierce them, two demons fall to the ground and three others, armed with shields and swords, run bellowing away. Rama in slate blue armor continues to shoot at them.

Despite the unspeakable carnage in this picture, making it seem a miniature version of Picasso's *Guernica*, there is much to arouse delight. No one, except perhaps a devotee of the bullring, would exult in *Guernica*'s an-

guished horses, brutal bull and howling women, yet the formal qualities of that great picture and its maturely echoing tones give it a majesty that wholly transcends its grisly subject. In the present picture, an example of Style IV, a painter from Bilaspur has adapted Kahlur idioms to Kulu conditions, and against a background of the palest yellow has blended the determined figure of Rama with the wounded, mutilated and gruesomely horned figures of the demons. Each demon is a different color—rich brown, dark gray, mauve, sage green and brownish pink. Their postures fall into a rough-and-tumble order and even the severed limbs join with the swords and battle-axes to make a wild, ungainly pattern.

94

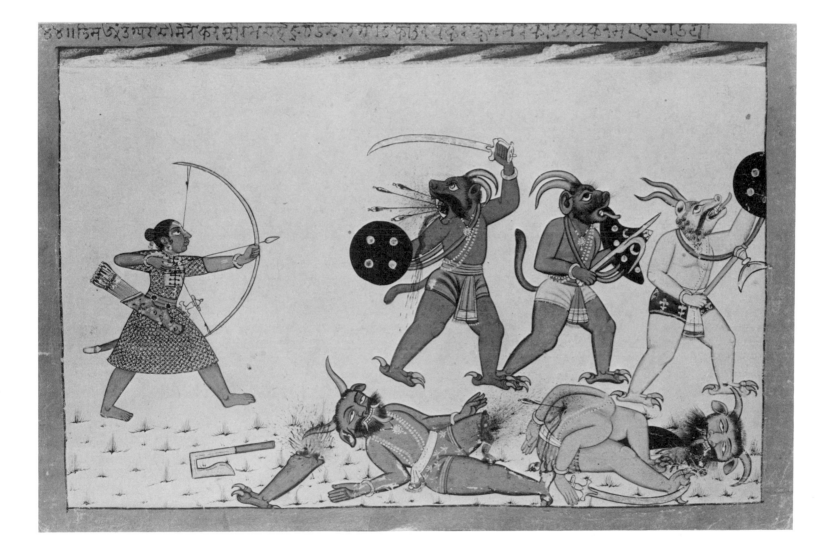

52. *Raja Anand Dev (c. 1690 – c. 1715) of Bahu (Jammu) with Two Maids*

$7^3/_4 \times 11^1/_4$ in. (with borders)
Inscribed at the top in *takri* characters: *sri ram ji(?) sri raj anad de* "May Rama be praised! Sri Raja Anand Dev (of Bahu, Jammu)"; and on the reverse: *raja anand de*

A portrait, possibly commemorating the visit to Kulu of the young Bahu ruler Raja Anand Dev, in whose reign the Bahu portion of Jammu state was fused with its rival, Jammu proper. The visit may have coincided with celebrations of the Kulu state god, Raghunath—a surmise perhaps warranted by the invocation to Rama in the inscription.

The present portrait illustrates the extremities of mannerist distortion in which Kulu painters seem to have reveled. Against a sage green background, the prince is shown with an overenlarged head and overminute waist. A gigantic pale blue bolster supports his thin triangular torso, and an overlong thigh juts brusquely out towards a squatting maid whose knee comes forward to meet it.

The prince's *jama* is a golden yellow, the maid's dress a slate blue. Nothing in the picture is normal. The great hookah-bowl, instead of resting on the rug, is held by the maid pressed against her other knee. Its stem loops between them, and the prince's hand emerges from behind the bolster to hold it. Each maid has the briefest of bodices and seemingly no breasts; and even the pinkish stripes on the dull red rug splay out in different directions. However Basohlilike are the eyes and foreheads of the two maids, the disjointed poses, dislocations of anatomy and wilful conjunction of strange poetic colors give the scene a haunting Kulu flavor.

Publ.: Archer, *Indian Paintings from the Punjab Hills* (1973), Kulu no. 11.

96

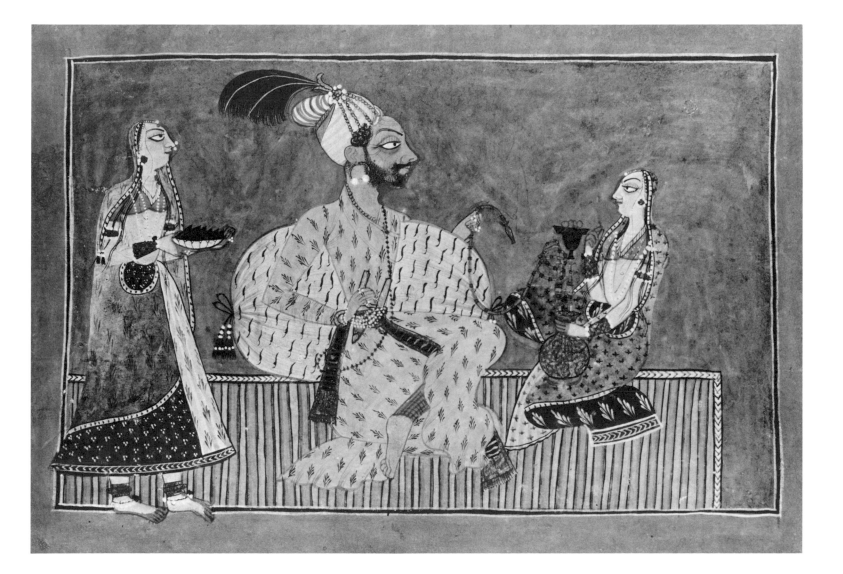

KULU, C. 1700–1710

53. *Kedara Raga*

From a *Pahari Ragamala* series
$6^1/_4 \times 6^1/_4$ in.
Inscribed at the top in *takri* characters: *kedara
raga megh rage da putra* "Kedara Raga, son of
Megh Raga"

Like 52, this picture continues the interest of Kulu paint-
ers in "extreme situations." The exaggerations are less
marked but there is the same emphasis on minor oddities
of posture and on daring confrontations of color.

A prince wearing a dark orange *jama* and a mauve
turban, a long sword in yellow scabbard slung from his
waist, sits on a lime green rug frothy with swirling spray-
like patterns. He holds in his right hand a huge blackish
gray bow and in his left an enormous arrow with a
spearlike tip. Behind him against a chocolate brown
background, subtly suggestive of utter darkness, rises a
thin tree with chalky pink trunk and seven rosettes of
leaves. A thin creeper mounts the trunk and issues at the
top in a hood of drooping red stems with white flowers.
Facing the prince and seated on the ground is a lady in
dark red dress edged and sprinkled with black, her hands
heavily hennaed and her arms crossed on her lap. Each

gazes at the other with a seemingly unbreakable stare.
It is as if a symbolic encounter has occurred but its
meaning and outcome are unpredictable.

As for the role of the great bow and arrow, an oblique
reference by the Waldschmidts to Kedara *Raga* as a
young warrior delighting in yoga and in Shaiva medita-
tion suggests that these weapons are in some way con-
nected with "the bow of Shiva." The fact that the prince
wears Shaiva tilak marks on his forehead may also have
some slight bearing on the matter. The Kangra version of
Kedara *Raga*, on the other hand, omits the bow and
arrow, shows no encounter with a lady and merely por-
trays a prince listening to musicians under a canopy at
night. A Baghal version of the same *raga* comes closer to
the present treatment but shifts the scene from the forest
to a lover's lodging, diminishes the size of the bow and
arrow and extinguishes the gap between prince and lady.

98

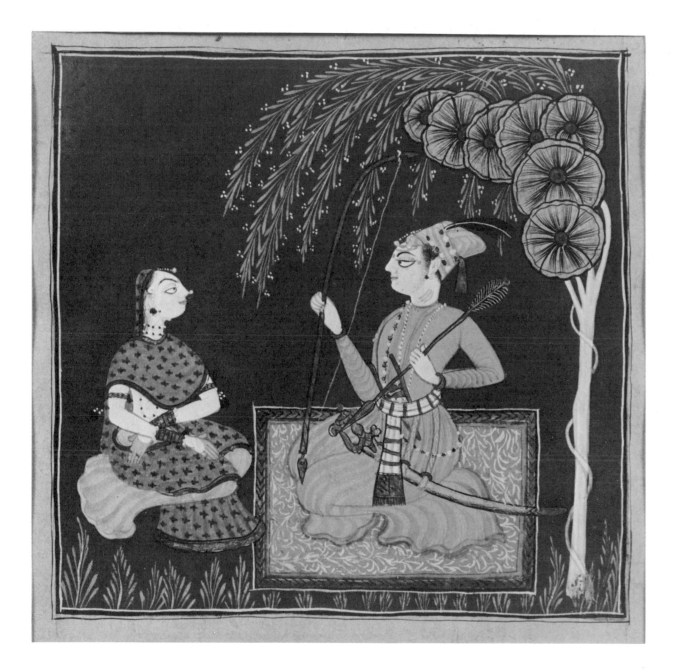

KULU, C. 1720

54. *Baz Bahadur and Rupmati Riding
 at Night*

$7^1/_2 \times 11^3/_4$ in. (with borders)

Like the walls of Magnus Martyr in T. S. Eliot's *The Waste Land*, this picture has an "inexplicable splendour." The riders are Baz Bahadur and his mistress, the Hindu courtesan Rupmati, fabled for the passionate intensity of their romance at Mandu in central India. They were said to ride together each night gazing into each other's eyes. Here they are seen trotting out into the blackness, mounted on great horses with large croups, each holding a hawk and attired in a dazzling variety of entrancing shades. Rupmati is looking back as if surprised by some casual wanderer. Baz Bahadur is moving as if in a dream. Of the two horses, one, a white stallion, is decked in dark red saddlery and a black and yellow girth, fringed with swaying tassels. Its rider, Baz Bahadur, flaunts striped green trousers, covered by a muslin overgarment which ripples below him. Rupmati's horse, a light brown, is matched by a great hound that lollops beside them. As they penetrate the night, each horse casts a wary, startled eye as if sensing unseen danger. Ahead is a girlish page-boy, half-kneeling and with eyes half-shut, lifting a long blue and yellow matchlock which might have come from Wonderland. The target is a line of wraithlike cranes, perched, dimly visible in trees and bushes, their legs and crests a pale blood-red. The youth is aiming as if in a trance and indeed the whole progress has an air of tranced and dazed wonder. Yellow calls to yellow, red to red, white to white and everywhere rippling lines utter curvacious spells. If any single picture could embody the eerie enchantments of Kulu, it could well be this.

Publ.: W. G. Archer, *Indian Miniatures* (1960), col. pl. 70; G. Lawrence, *Indian Art: Paintings of the Himalayan States* (1963), col. pl. 13 (detail); Mildred Archer, W. G. Archer and Sherman E. Lee, *Indian Miniatures from the Collection of Mildred and W. G. Archer* (1963), pl. 29; Mildred and W. G. Archer, *Romance and Poetry in Indian Painting* (1965), pl. 27.

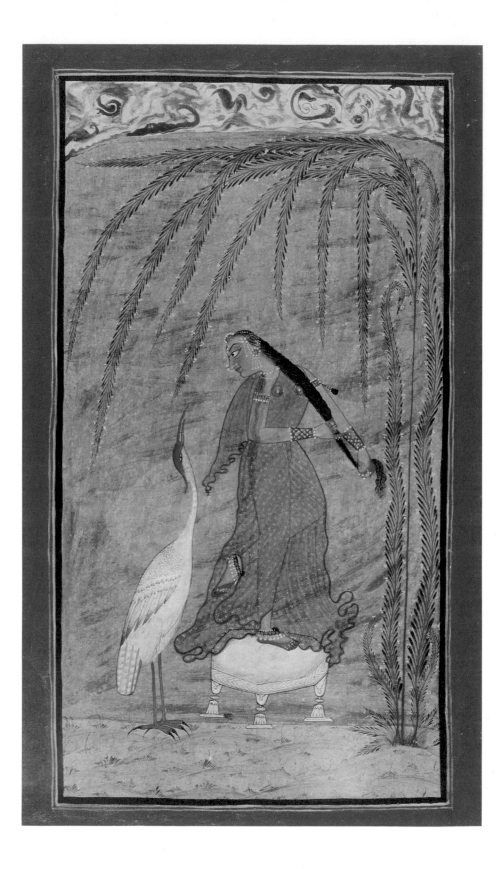

55. *The Lady and the Crane*

$9^{1}/_{2} \times 5$ in.

In Indian painting and poetry, peacocks and cranes, their long necks raised in hopeless yearning, were often employed as symbols of unappeased desire. In this picture, the subject is a woman at her toilet, nude save for a flimsy muslin shift, dressing her hair after the bath. She has adorned herself with pearl nosering, pearl headdress and necklace and with gold bangles, and it only remains for her to don her clothes. Paralysis, however, has intervened. In a gust of Kulu angst, she is standing on a low bathing stool, her left foot nervously rubbing her right leg, her eyes distractedly turned away and her hands tugging at a long strand of taut black hair. Her shift, a pale blood-red, surges around her, its rippling edges mimicking the frantic nature of her thoughts. Beside her stands a crane, its long neck straining upwards, its pale blood-red crest and legs echoing the color of her dress, and its open beak seeming to utter a hoarse cry. Around and above her straggle a series of willow branches, their very disorder stressing her tumult.

The situation is one of neurotic tension, yet the painting has a glamorous potency. Although the background is shot through with wilful smudges of murky gray, its golden yellow is brilliant as sunshine. And the clouds that swirl confusedly, at the top, like Kulu mists, contribute, through their blue, white and crimson colors, to a final effect of quiet glory. Above all, the pale blood-red of the woman's shift imparts a magical incandescence.

It is symptomatic of Kulu weirdness that the woman has long strong legs, negligible waist, small torso, a hair-thin vulva and two tiny breasts, built up out of layers of paint and set audaciously askew across her chest.

KULU, C. 1720–1730

56. *A Lady at Her Toilet*

8 × 3 ³/₄ in.

Like 55, this picture is a study in exhilarating despair. The woman's toilet is now more advanced. She has put on golden yellow trousers. A flimsy shift sprinkled with three-dot patterns spreads around her. Her ornaments are duly arranged and she is now in the act of studying herself in a mirror held up for her by a short maid in brown veil and gray-green dress. If her lover were to come, she would be almost ready. Any upsurge of erotic joy, however, is belied by the chilly bleakness of the silver gray background and by the blackish clouds which snarl above her. There is a sense of nervous apprehension and a gathering "loss of nerve." Instead of jutting downwards in a sharp defiant thrust, her black hair droops in three sad prongs. Her bust is tiny, her breasts minimal. Yet the picture exhilarates, and this can only be due to the golden glory of her clothes, the blackness of her hair and the wild varieties of poetic color in the maid's attire —as wonderful in their conjunction as in the dresses of Baz Bahadur and Rupmati (54).

Publ.: Mildred Archer, W. G. Archer and Sherman E. Lee, *Indian Miniatures from the Collection of Mildred and W. G. Archer* (1963), pl. 32.

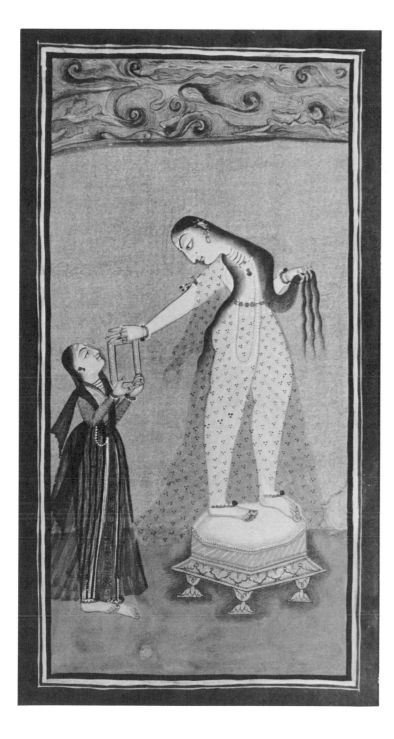

KULU, C. 1790–1800
By Bhagvan

57. *Angada Raga*

From a *Pahari Ragamala* series
$8^{1}/_{2} \times 6$ in.

Under Raja Tedhi Singh (1742–1767) of Kulu, the vehement distortions and convulsive posturings of early Kulu painting yielded to a style of greater calm. The crucial years were 1760 to 1765 and the occasion could have been the arrival in Kulu of one or more further artists from Kahlur (Bilaspur). Kahlur had been on good terms with Kulu throughout the seventeenth and eighteenth centuries and its painting had been marked by simplifying geometry and by the inclusion of architectural backgrounds for formal purposes. It had favored *ragamala* subjects and had featured a special shade of pale yellow as a foil to hotter colors such as red, orange-red and brown. Between 1760 and 1770 it introduced into painting a new architectural motif, the "fish-scale" pattern. Kulu paintings of the years 1760 to 1800 reflected these

traits but it was during the last fifteen years of the century that the change of style became most marked. Tedhi Singh's son and successor, Pritam Singh (1767–1806), was on the throne and under his patronage a painter named Bhagvan produced a group of sets, including a *Bhagavata Purana* dated 1794 and a "first" *Madhu Malati* series dated 1799.

The present picture is notable for the towering majesty of the princely lover and his lady, the stark simplicity of its brown and gray setting, its use of the "fish-scale" pattern as the chief architectural motif and for the blunt and square-shaped treatment of the faces. Despite the mute gravity of the couple, the orange-red of the lover's face, hands and feet is so fiery that their statuesque reserve must quickly melt.

106

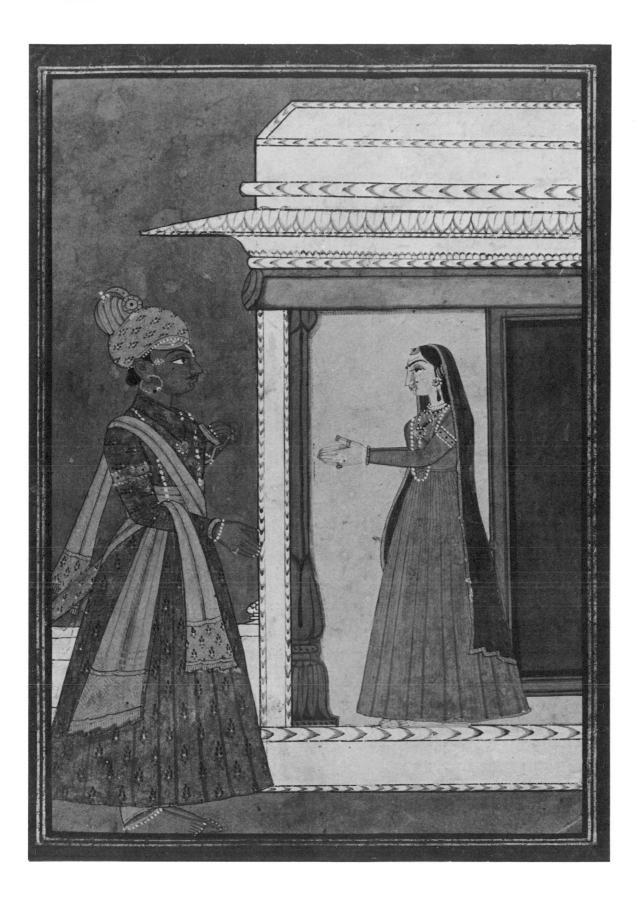

KULU, C. 1790–1800
By Bhagvan

58. *Krishna and Companions in a Grove*

From a *Rasa Panchadhyayi* series
$6^{1}/_{2} \times 8^{1}/_{2}$ in.

Like the *Gita Govinda* of Jayadeva, this poem focuses on the romance of Radha and Krishna, its abrupt changes and final enraptured ending. Unlike the *Gita Govinda*, however, it introduces the sage Narada, patron of music, as master of ceremonies. The bearded Narada is here shown standing on the right between three cowgirls. Krishna, an agitated figure to the left, distractedly searches for the abandoned Radha.[1]

1. For other paintings by Bhagvan, see Archer, *Indian Paintings from the Punjab Hills* (1973), Kulu nos. 36–41.

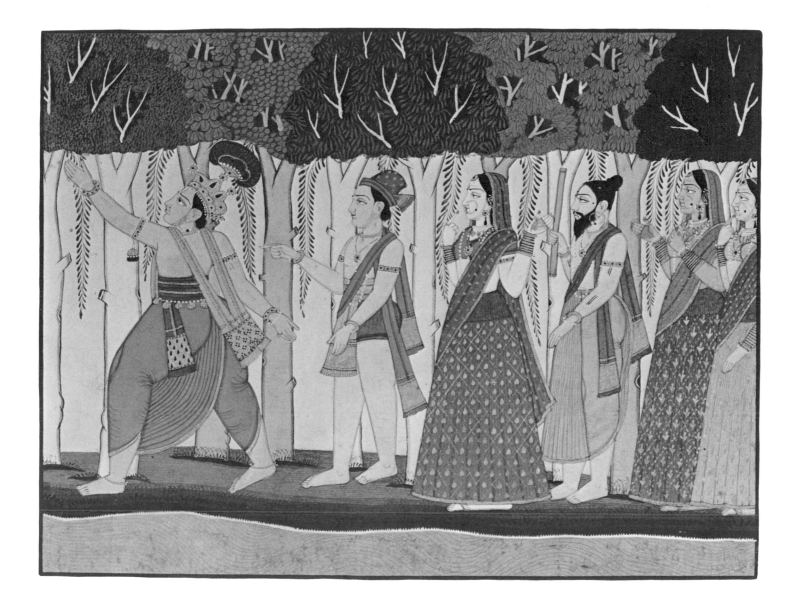

MANDI

59. *Raja Shamsher Sen (1727–1781) of
Mandi Smoking*

$8^3/_4 \times 7$ in.
Inscribed at the top in *takri* characters: *sri davan*
 "Chief Minister"

Since Mandi and Kulu were neighbors, they were normally bitter rivals, and it was only in the nineteenth century that feudal sorenesses were overcome and the two families intermarried. While painting in Kulu evolved out of painting in Basohli, Mandi had gone its own way. Like Mankot (see 63) it had begun by specializing in portraiture and from the end of the seventeenth until the beginning of the nineteenth century, its artists celebrated with bucolic coarseness the prowess of its various rulers.

Although the nonogenarian giant Raja Sidh Sen (1684–1727) had achieved a legendary stature with his great sword and book of spells, the present subject—his grandson, Raja Shamsher Sen (1727–1781)—was noted for mental instability, a wilful liking for "low companions," "crazy habits" and even at times for odd "dressings-up." Indeed, without the stabilizing influence of his twin brother, Dhurchatia, Mandi might well have collapsed. Here the great lazy figure, loaded with a thick garland and tasseled flowers, his oafish face puffing out spirals of hookah smoke, looks vacantly at the old courtier who respectfully stands before him with a staff of office.

The title of "Chief Minister" given to the Raja in the inscription on the picture is a reference to the fact that, like Kulu, Mandi had been surrendered to a ruler-god, Madho Rai, an image of Vishnu. The rajas acted as its regents and hence bore this title.

Publ.: Mildred Archer, *Indian Miniatures and Folk Paintings* (1967), fig. 31; Archer, *Indian Paintings from the Punjab Hills* (1973), Mandi no. 36; Archer, *Pahari Miniatures: A Concise History* (1975), pl. 18.

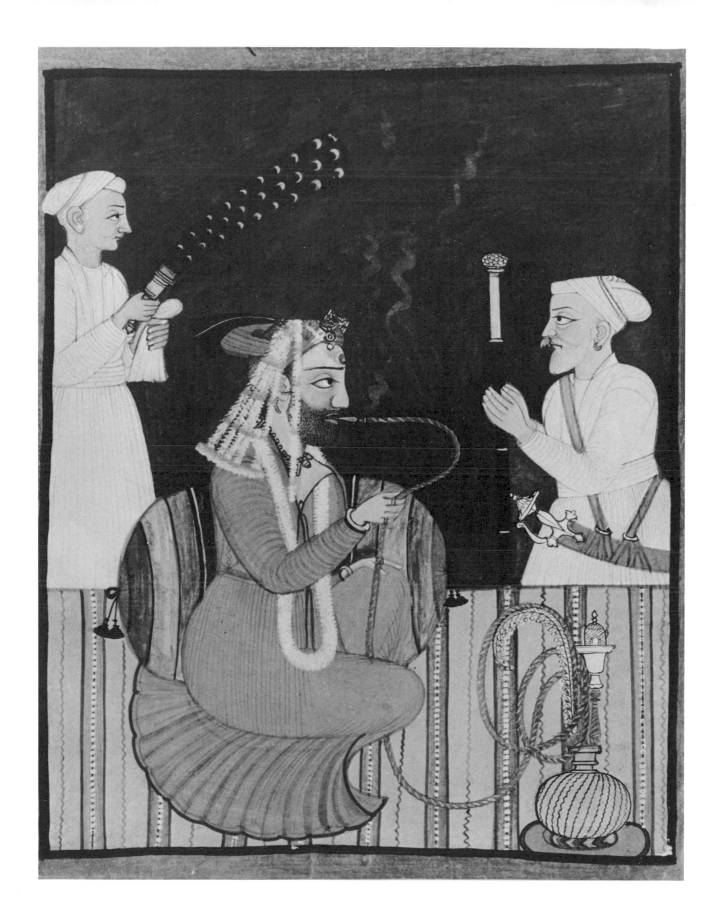

60. *The Holy Family*

9 ¹/₂ × 6 in.

Although Madho Rai, an image of Vishnu, was Mandi's state god, the cult of Shiva and the Devi attracted wide homage in the form of temples and popular worship. Pictures of Krishna and the cowherds were admittedly painted from time to time, but it was chiefly in studies of the five-faced Shiva, or of the tantric Devi brandishing a wild sword, that local painters specialized.

This picture shows Parvati in a plum-colored dress holding her baby, the elephant-headed Ganesha, on her lap and proceeding placidly through a bare and hilly landscape dotted with trees like speckled mushrooms. The white bull Nandi, on whom she rides, witnesses to Shiva's procreative powers. Shiva with radiant white skin, and wrapped in a leopard skin, holds the young six-headed Skanda on his shoulder and watches their ambling progress.

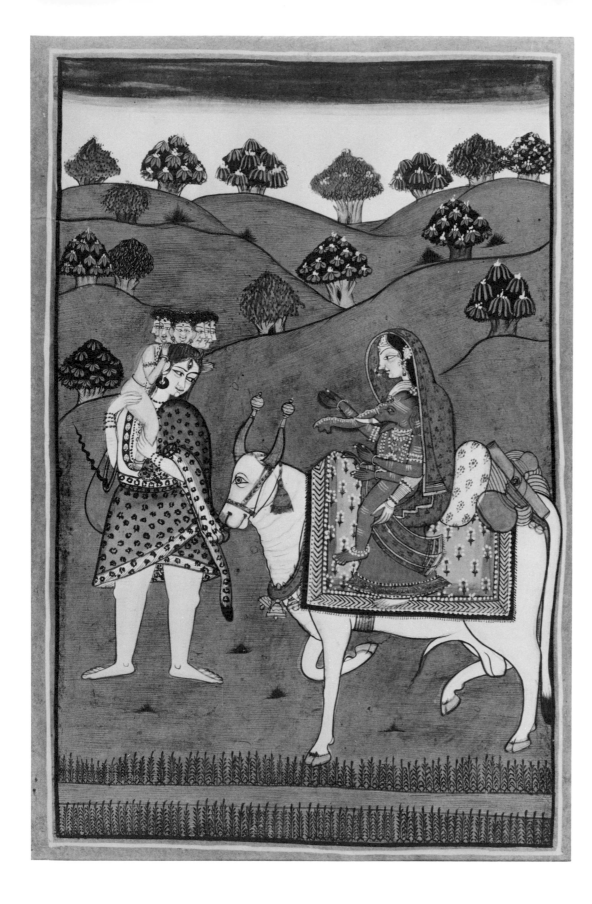

MANDI, C. 1760–1780

61. *Lady at Her Toilet*

$11^3/_4 \times 8^1/_4$ in. (with borders)

Although this picture has certain resemblances to Kulu painting (compare, in particular, the toilet theme, the intent downward-looking gaze of the lady, the jagged footstool, and the "fish-scale" decoration on the pavilion), other details firmly connect it with Mandi. These are the special type of veil drawn loosely across the bust and allowed to hang in broad loops, the "basket-work" patterning, the sharply cut features and long eyes, the midget trees spotted with blossom (see 60) and perhaps above all, the pink striped rug with wriggly lines between each stripe. This last detail is seen in almost all Mandi portraiture of the period. It is noteworthy that, in contrast to similar paintings in Kulu, the mood is one of proud sensuousness, the lady glorying in her graceful pose, briskly glancing at her reflection in the mirror and reveling in the group of gorgeously attired maids who watchfully surround her.

Publ.: Archer, *Indian Paintings from the Punjab Hills* (1973), Mandi no. 30.

114

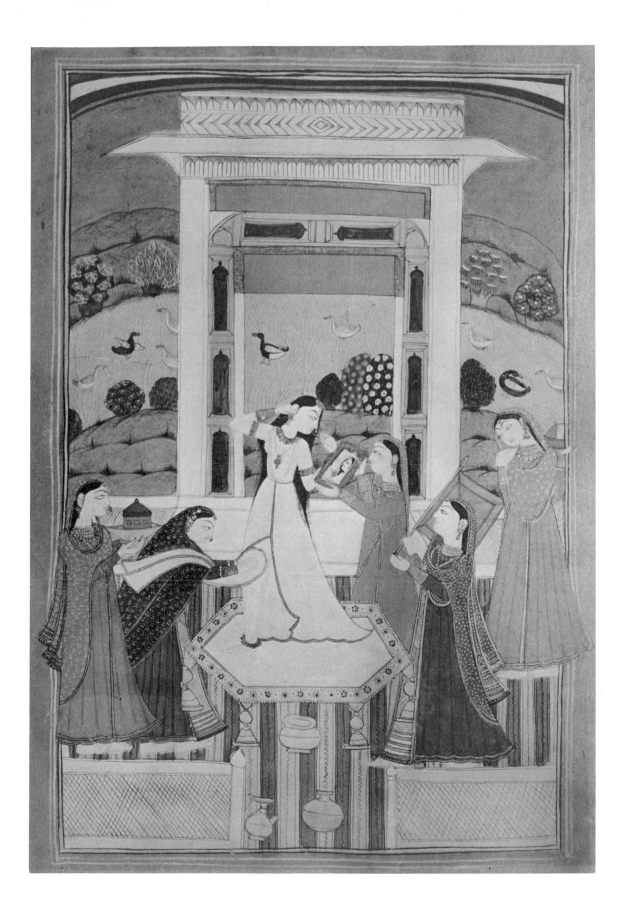

MANDI, C. 1810–1825
School of Sajnu

62. *The Expectant Lady*

$6^1/_4 \times 9$ in.

Under Raja Isvari Sen (1788–1826), painting in Mandi made that sharp break with previous tradition which at one time or another appears to have occurred in almost every Pahari state. Isvari Sen had been a captive at the art-conscious court of Raja Sansar Chand of Kangra from 1793 to 1805, and on his release it seems probable that he engaged a Guler painter, Sajnu, to work at his court. It was Sajnu who introduced a new manner deriving from his Guler or Kangra experiences.

Here, the theme is once again the plight of a love-deprived woman, looking out from her empty house and scanning the busy landscape for signs of her absent lover. Her features are in line with a Guler-Kangra type of face that was naturalized at Mandi by Sajnu and his followers. The poetic treatment of the gathering storm and of the multi-colored hills may have been suggested by the appearance of a valley at the southern end of the state. "Sukyt-Mundi," wrote the traveler Vigne in 1842,

is eight or ten miles in length and three or four in breadth, richly cultivated and containing numerous villages; and on each of the picturesque hills around are numerous forts and perhaps no country of equal extent could boast of so many strongholds or what appear to be such. In the centre of the valley the Sukyt stream is joined by another from the Rawala Sar or small lake at some distance in the mountains.

When I myself visited the valley in 1960, it still had a breathtaking loveliness, symbolically captured in the picture by the juxtaposition of radiant pinks, blues, greens and yellows.

116

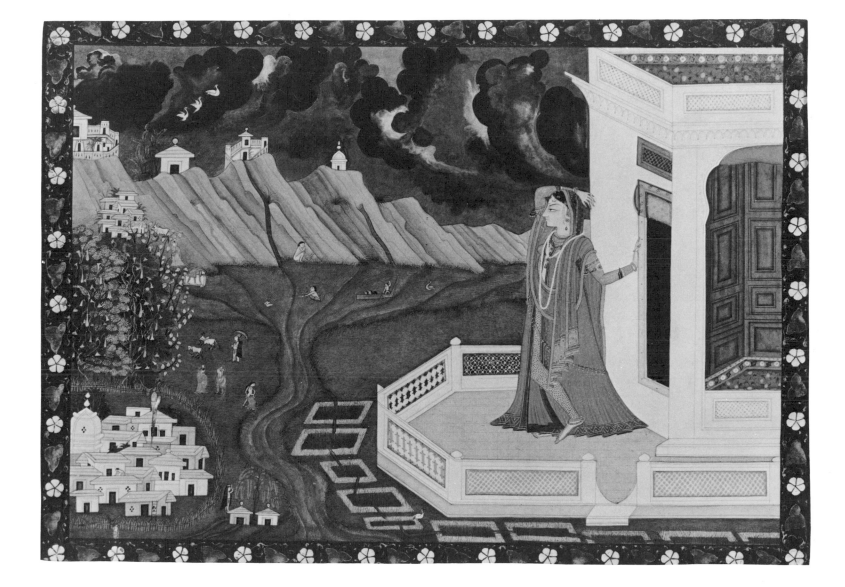

MANKOT

MANKOT, C. 1680

63. *Raja Mahipat Dev (c. 1660 – c. 1690) of Mankot Smoking*

$8^{1}/_{4} \times 8^{1}/_{4}$ in.

Lying some twenty miles northwest of Basohli, Mankot possessed in the seventeenth century an enormous fortress-palace every bit as large as that of Basohli. Straddling a long, high ridge and with airy views across a valley to a range of further hills, it was a huddle of broken walls, fallen masonry, shrubs and cactuses when I climbed up to it in 1970. Much of the outer wall in brownish pink brick still stood; there were traces of a great hall and within the perimeter were vestiges of a small Murli Manohar (Krishna) shrine. Returning down the long flight of stone steps which led to the village, I was awed by the height of the steep cliffs on which the fortress stood, its massive scale and dauntingly strong position. Although originally an offshoot of Jammu, the state was fiercely independent of its neighbors, but like them had tendered submission to the Mughal emperor Akbar in the late sixteenth century.

Mahipat Dev, with his burly figure, hooked nose, trim beard and cool air of bold aplomb, looks the very embodiment of feudal might. In contrast to his father, the blind Raja Sital Dev, he had avidly responded to current developments and, besides introducing ardent Vaishnavism to Mankot, had established a flourishing school of local painters. Their first speciality was portraiture, and while their style owed much to Mughal portraiture of the Shah Jahan period, it was already Rajput in its use of flat planes, scorn of depth and perspective, and predilection for broad expanses of golden yellow. These characteristics are seen to advantage in the present picture.

Publ.: Archer, *Indian Paintings from the Punjab Hills* (1973), Mankot no. 9; Archer, *Pahari Miniatures: A Concise History* (1975), pl. 5.

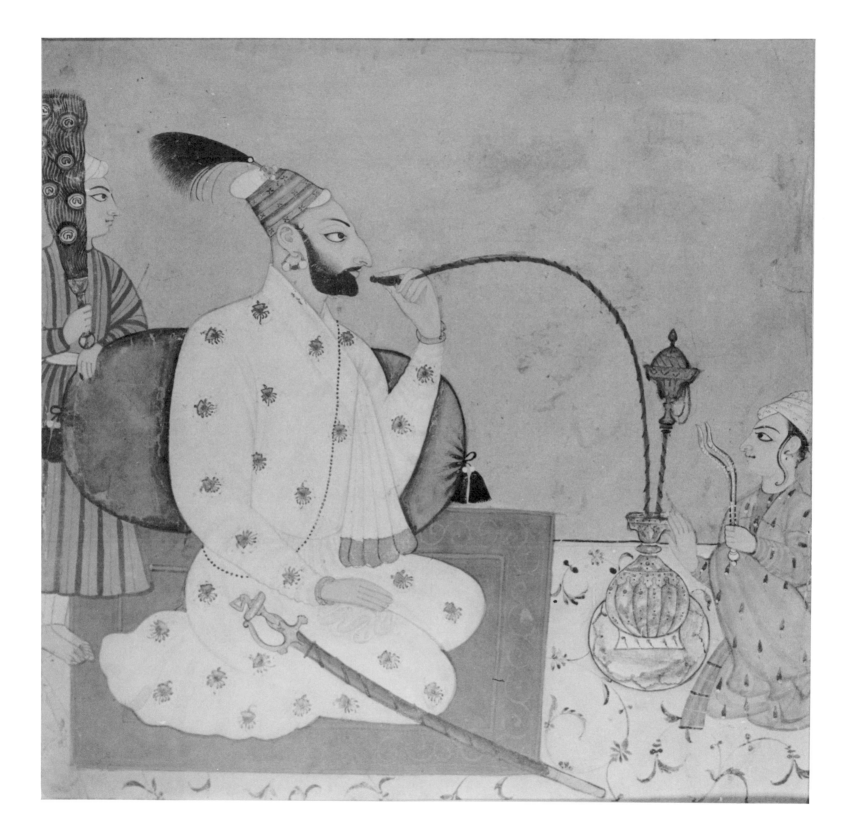

MANKOT, C. 1700

64. *Raja Dalip Singh (1695–1741) of Guler Seated with His Personal Priest*

$8^1/_4 \times 6$ in.

Inscribed on the reverse in *takri* characters: *raja dalip singh purohit dinath* and in *nagari* characters a prayer in Sanskrit

Besides celebrating their own rulers, Mankot painters included among their subjects local courtiers, priests and personal servants. Almost anyone of consequence or character was portrayed, and in no other Pahari state was there such a flurry of portraiture or so comprehensive a record of persons great or small.

The artists also portrayed neighboring rulers and in this picture the young Dalip Singh (1695–1741) of Guler is shown smoking a hookah and holding the hand of his personal priest, the Brahmin Dinath. Dalip had ascended the Guler throne at the age of seven and, surviving an attempt by Jammu to unseat him, had later confirmed Guler as an effective presence in the Hills. Since he adhered to ardent Vaishnavism, fears for his future may have led his mother, the queen regent, to dedicate a temple to the Devi in a village three miles from the Guler capital, with the hope of securing "long life for Dalip, well-being to him and his people and perpetuity to her family." Her prayers could well have been answered, for during his reign Guler suffered no further setbacks and enjoyed unbroken peace. Dalip himself showed his piety by founding various temples, but he was no milksop and played polo with the masterly vigor of a Prince Philip or Prince Charles. His obvious capacity for stern intervention may have prompted the verses on the back of this picture: "Such was the prowess of his mighty arms that he could destroy the forests, the haughty ones and all his enemies. [Such arms of] Raja Dalip Singh should ever protect us."

Publ.: Archer, *Indian Paintings from the Punjab Hills* (1973), Mankot no. 19.

120

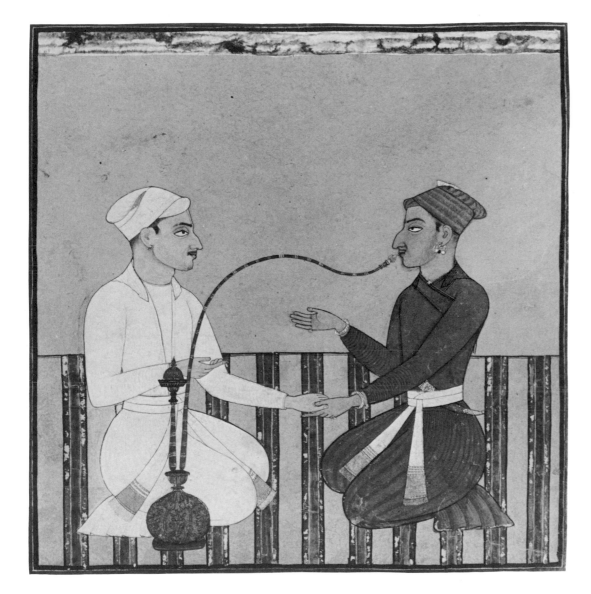

MANKOT, C. 1700–1710

65. *The Monkeys Gather Fruit*

From a *Ramayana* series, *part 4, Kishkindha khanda*

$6^{1}/_{2} \times 10^{1}/_{2}$ in.

Although Vaishnavism tended to concentrate on Krishna and his cowgirl loves, Vishnu's earlier incarnation, Rama, was by no means neglected and in almost all Pahari states one or more *Ramayana* series were produced either before or at the same time as paintings in praise of Krishna.

Under Mahipat Dev (c. 1660 – c. 1690) cordial relations with Basohli had led to the induction of his daughter as second and favorite rani of Raja Kirpal Pal (c. 1678–1693) of Basohli. This state had already developed a magnificent style of barbaric luxury (see 5) and as a by-product of the marriage two developments may have occurred. The Mankot zest for Vaishnavism could have fortified the Basohli court, and Basohli painting could have given a new injection to painting at Mankot. The result is seen in the production at Mankot of a *Ramayana* series (65, 66) at least two *Bhagavata Puranas*—one horizontal, the other vertical (68)—and various pictures of deities including Shiva, the Devi and the incarnations of Vishnu. In these pictures, Basohli influence accounts for a greatly widened range of brilliant color and for the use of free distortions, but the ultimate style, with its swirling rhythms, strong and sturdy forms, avoidance of rich or intricate details and gay anarchic spirit, differs sharply from that of either Basohli or Kulu.

In the present example events are telescoped into one narration. Exhausted by their vain scouring of the forests in quest of Sita, Rama's monkey allies spy the entrance to a great cavern (shown as a gray shape in the left foreground). They enter it and discover a fantastic underworld of gardens, orchards and lotus ponds. Here they slake their thirst and devour pomegranates. As they wander, they light upon a female ascetic in whose charge the cavern has been placed. She summons Hanuman, the monkey Angada and the bear Jambavan, explains her identity and warns them that only with her aid can they hope to emerge from the cave alive. They explain what has brought them there, and on condition that they close their eyes, she gives the party safe conduct. The monkeys obey and return without mishap to the outside world.

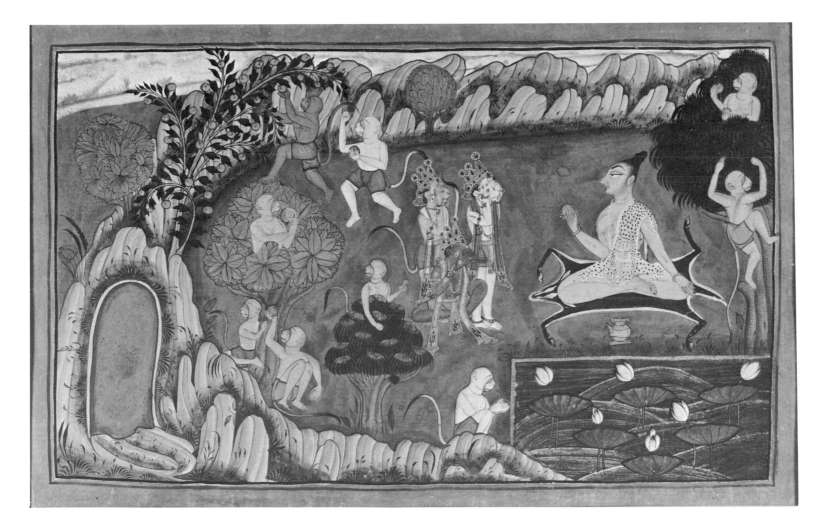

66. *The Vulture Reports to the Monkeys*

From a *Ramayana* series, *part 4, Kishkindha kanda*
$6^1/_4 \times 10^1/_2$ in.

Following their adventures in the cavern but disheartened by lack of success, the monkeys are tempted to abandon their mission and fast to death. They are rallied by Sampati, "vulture" brother of Jatayu (killed by Ravana while abducting Sita), who reports Sita's whereabouts in Lanka (Ceylon) and induces them to go south.

In the picture, the party's leaders are seated in conclave on a bare green hillside with the bird Sampati standing before them. Trees with leaves in rosettes and gray trunks, interwoven with creepers, form a bower. A band of tangled sky and a group of jagged boulders echo their bewilderment but the insouciance with which two youthful monkeys are comparing notes, and the rhythmical pattern formed by the looping tails and creepers give the picture an air of gay abandon.

124

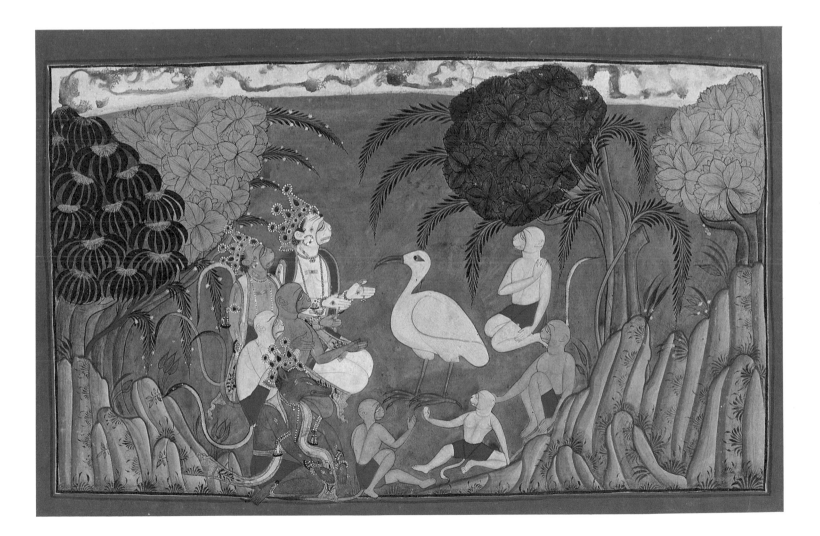

67. *Gambhira Raga*

From a *Pahari Ragamala* series
$6^{1}/_{4} \times 6^{3}/_{4}$ in.

Gambhira *Raga* (a son of Sri *Raga*) is symbolized by a courtly couple in a mauve boat, being poled across a swirling brown river. As the boat moves through the foam-flecked water, the prince aims an arrow at a pair of black bucks on the further shore. Three midget trees temper the plain green background.

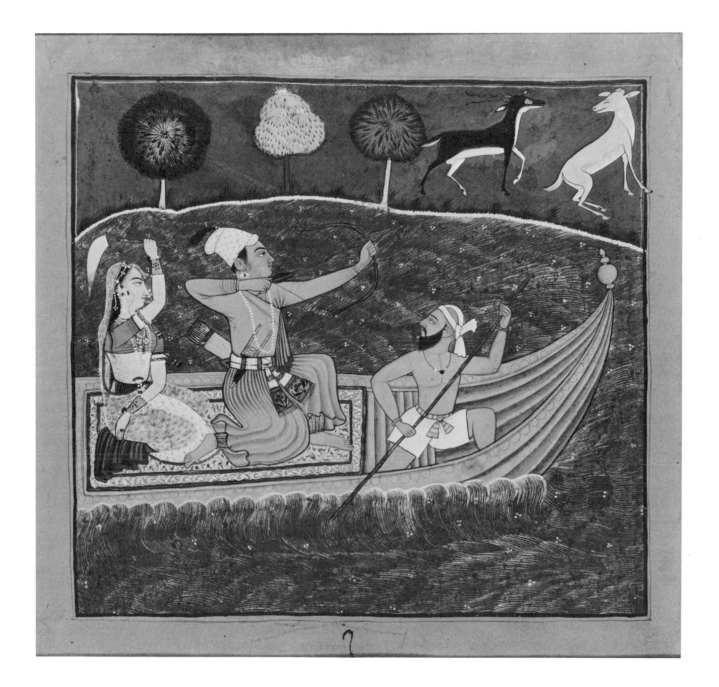

MANKOT, C. 1730

68. *Kaljaman Pursues Krishna*

From a "third" (vertical) *Bhagavata Purana* series
$11\frac{1}{4} \times 8\frac{1}{2}$ in. (with borders)

This is a picture of stark magnificence. Each form is rendered with firm precision; tiny details are unobtrusively inserted and the two fighters—Krishna with a cowherd's crook raised aloft, Kaljaman with a great sword projecting into the border—go prancing by like dancers in a ballet.

Krishna is, in fact, decoying the demon king Kaljaman away from his army by pretending to flee. He keeps a hand's distance from him and leads him to a cave where Kaljaman kicks a sleeping sage. The sage gives him an angry look and burns him to ashes. Krishna then returns to dispatch Kaljaman's demon army.[1] It is significant that although the incident occurs long after Krishna has left the cowherds and has assumed his role of feudal prince in Mathura, he continues to carry, as his identifying emblem, a cowherd's crook.

1. For a description of Kaljaman and of Krishna's prior evacuation of the Yadavas to Dwarka, see W. Hollings, *The Prem Sagur* (1880), chapter 52.

Publ.: Archer, *Indian Paintings from the Punjab Hills* (1973), Mankot no. 36(iii).

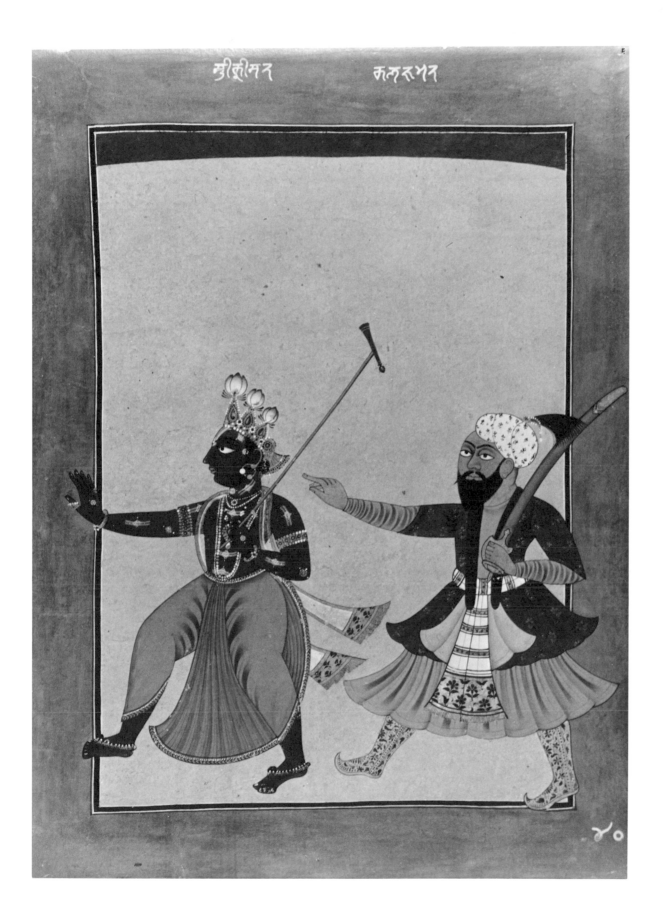

69. *Raja Ajmat Dev (c. 1750 – c. 1765) of Mankot Smoking*

$8^1/_4 \times 8^1/_4$ in. (with borders)
Inscribed on the reverse in *takri* characters: *sri raja sri ajmat de ji*

This is a companion picture to 68, applying to portraiture the same simplifying clarity. The floral scrollwork on the rug subtly matches the twining loops of the hookah stem and the swirl of the pageboy's sash. The background is again a golden yellow and gives a burning grandeur to the serene mien of the dignified prince.

Publ.: Mildred Archer, "Indian Miniatures," *Art International* (1963), VII, no. 9, 20; Mildred Archer and W. G. Archer, *Romance and Poetry in Indian Painting* (1965), pl. 26; Archer, *Indian Paintings from the Punjab Hills* (1973), Mankot no. 33, col.

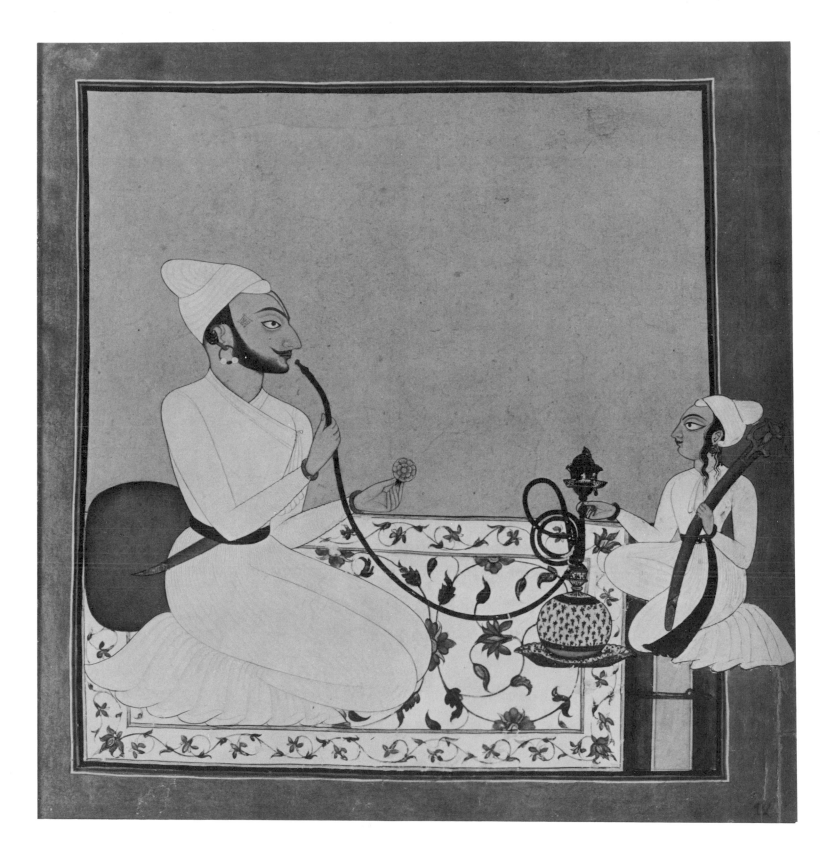

NURPUR

70. *Achanda Raga*

From a *Pahari Ragamala* series
$7 \times 6^{1}/_{2}$ in.

Crowning a large bluff at the entrance to the Kangra valley, the little town and fort of Nurpur extends for a mile and a half along what Hugel called in 1845 "a tabular space." For much of the seventeenth century, it supplied the Mughal court with leading generals, its rajas campaigning far and wide for the imperial cause. Under Raja Jagat Singh (1618–1646), it reached the height of its power and dominated both Basohli and Chamba.

At the end of the sixteenth century, a Krishna temple had been built inside Nurpur Fort; destroyed in 1618, it was replaced by Jagat Singh some ten to twenty years later. While constructing his new shrine, Jagat Singh visited Mewar and returned with an image of Krishna in black marble which had formerly been installed in the fortress of Chitor. His grandson, Raja Man Dhata (1661–1700), established yet another Krishna shrine in the state, and, when decorating it with murals of Krishna, had his own portrait included among them.

In the present picture, Achanda *Raga* (son of Sri *Raga*) is represented by a pair of lovers sitting in each other's arms, their eyes intently fixed on some occurrence that is happening outside. Above the courtyard wall rise three spear-shaped cypresses—emblematic of mounting passion—and the mood of sultry desire is further suggested by the hot orange of the background repeated in the prince's *jama*. A feature of the picture is its use of dark blue and a delicate, faint mauve—colors which characterize much early Nurpur painting. The picture comes from a set of *Ragamala* pictures, in one of which the lover's face is clearly modeled on that of Man Dhata himself.

132

NURPUR, C. 1710

71. *The Lover Prepares to Go*

From a *Rasamanjari* series
$6^{1}/_{2} \times 10^{1}/_{2}$ in.

While artists at Nurpur were developing a local style of painting at the end of the seventeenth century, one of them, the painter Devidasa, took service with Raja Kirpal Pal (c. 1678–1693) of Basohli. In 1660–1670, a "first" *Rasamanjari* series had been executed at Basohli, substituting Krishna for the courtly gallants who figured in Bhanu Datta's original poem. In 1680–1685, a second series was produced, eliminating Krishna except when he was specifically mentioned in the verse, and depicting the lover as the poet had intended him. The series must have captivated Kirpal Pal's imagination for in 1693, some months before he died, he commissioned another set "in order to see the creation of God and to realise the hollowness of the world." His choice fell on Devidasa, "well versed in the art of painting," who completed the series in January–February, 1695, almost two years after his patron's death. His version is in clear Basohli style but employs simpler and bolder compositions, less vehement eyes, more roundly shaped heads and somewhat softer colors.[1]

Nothing is known of Devidasa's subsequent career and no other Basohli work can be confidently ascribed to him. It is possible that, later in the sixteen-nineties, he returned to Nurpur where his son, Golu, subsequently achieved renown.

The present series is in a markedly different style from that of the *Rasamanjari* which he had done for Kirpal Pal but it employs the same compositions, iconography and disposition of figures. It seems likely, therefore, that Devidasa's original designs remained in the family, and that either he or Golu used them for the present Nurpur series. A significant feature is the modeling of the courtly gallant in many of the pictures on Man Dhata's son and successor, Raja Daya Dhata (c. 1700 – c. 1730).[2]

In the picture, the lover, dressed in a long (almost ankle-length), yellow *jama*, is breaking to his mistress the news of his impending departure. His diffident approach is the acme of tact but the news is so abrupt that she has collapsed in stunned dismay. The blank white of the empty walls and the starkly simple setting suggest her lonely future. Beyond the room is the dark night, with two lines of leaf-shaped trees glowing like lamps in the gloom. A narrow band of sky sprinkled with stars employs the same cold blue as in 70.

1. For a discussion of the three Basohli *Rasamanjari*s, see Archer, *Indian Paintings from the Punjab Hills* (1973), Basohli nos. 4, 10 and 15.

2. Discussed and illustrated *ibid.*, Nurpur nos. 14(i–vi).

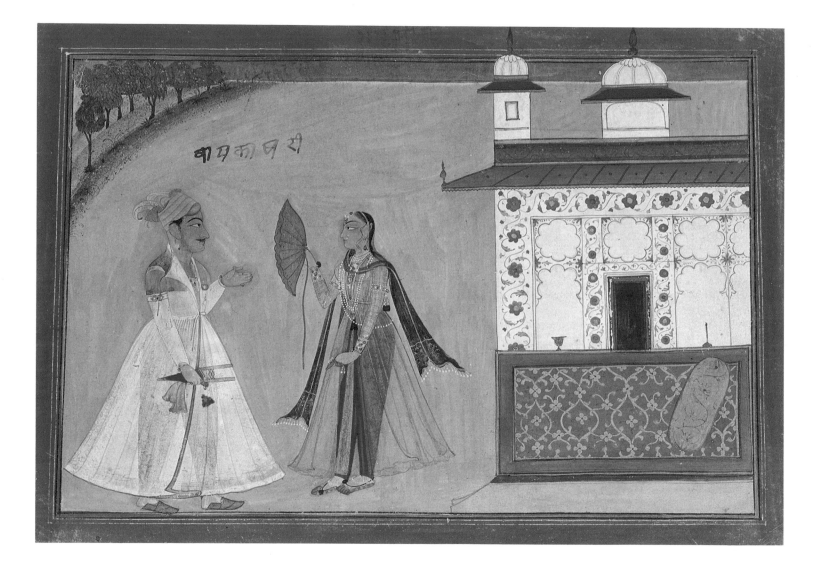

NURPUR, C. 1710

72. *The Sarcastic Mistress*

From the same *Rasamanjari* series as 71
$6^3/_4 \times 10^1/_2$ in.
Inscribed in *nagari* characters on the face:
nayaka khari "the standing gallant"; and on
the top border *madhya dhira* "the young
mistress who expresses her annoyance
sarcastically but remains basically affectionate"

A lady in dark red trousers, blackish green veil and transparent skirt stands outside a gaily decorated pavilion, holding a large lotus leaf in her hand. Before her stands the lover—his face closely similar to that of Raja Daya Dhata—clad in green trousers and transparent skirt and holding in his hand a dagger. Behind them stretches an expanse of yellow, no longer clear and bright but faintly sullied. A verse from the *Rasamanjari* explains: "My darling, you appear to be coming from a bower, full of a swarm of agitated bees, for your hot streaming perspiration afflicts you. I wish to comfort your limbs with this fan of lotus leaves" (trans. Randhawa and Bhambri). The meaning, as the translators explain, is only too clear. The swarm of agitated bees are other women to whom the gallant has been shamelessly making love and his mistress is gently scoffing at his obvious embarrassment.[1]

1. M. S. Randhawa and S. D. Bhambri, "Basohli Paintings of Banudatta's *Rasamanjari*," *Roopa Lekha* (1967), XXXVI, nos. 1 and 2, 17.

Publ.: Archer, *Indian Paintings from the Punjab Hills* (1973), Nurpur no. 14(i).

137

NURPUR, C. 1760
By Har Jaimal

73. *The Lady on the Terrace*

$9\frac{1}{2} \times 5\frac{1}{2}$ in.
Inscribed in tiny Persian characters on the
central clump of trees: *raqim har jaimal
musawwir* "By the (Hindu) painter, Har
Jaimal"

In this picture the stresses and tensions inherent in the Indian feudal order are vividly implied. The central figure, a princess or lady of the court, is seated on a tall gilt chair attended by four maids. She is whiling away the hours listening to two girl musicians. A bare white terrace stretches around them and there is an air of infinite isolation and listless boredom.

In the distance, far beyond the cold gray of a lotus pond which cuts the terrace sharply off from the outside world, a tiny prince in orange-red *jama* is riding a horse, accompanied by a soldier with sword and spear and two baggage carriers. He is making for a small pavilion, threading his way through the tumbled hills. Whether he is the husband of the lady or a casual rider can only be surmised, but the division of the picture into two such definite parts illustrates the contrast between the enclosed world of Pahari feudal ladies and the open countryside. In that countryside, village men and women go about in freedom; charcoal burners, their baskets strapped to their backs, trudge home; deer romp in the fields and cattle egrets perch on trees.

In terms of style, a striking feature is the deliberate elongation of feminine physiques, to be carried to even greater lengths in other Nurpur paintings of the period. The insertion of the Persian inscription, which flickers like a tiny white flower in the clump of trees, is teasingly mysterious. This is not because it is in Persian (the language in which much of Pahari business was conducted) but because it is where it is and is there at all. Although the names of many Nurpur painters have been discovered in recent years, only one other Nurpur picture is inscribed with an artist's name, Gur Baksh, and this is recorded in a straightforward way at the foot of the picture in a note identifying the subject, two gosains.[1] No other Pahari painting is known in which the artist's name is almost hidden in the landscape and in so minute a form.

1. Archer, *Indian Paintings from the Punjab Hills* (1973), Nurpur no. 21.

Publ.: W. G. Archer, *Indian Painting in the Punjab Hills* (1952), fig. 62; K. Khandalavala, *Pahari Miniature Painting* (1958), no. 183; Mildred Archer and W. G. Archer, *Romance and Poetry in Indian Painting* (1963), pl. 45; Archer, *Indian Paintings from the Punjab Hills* (1973), Nurpur no. 32.

138

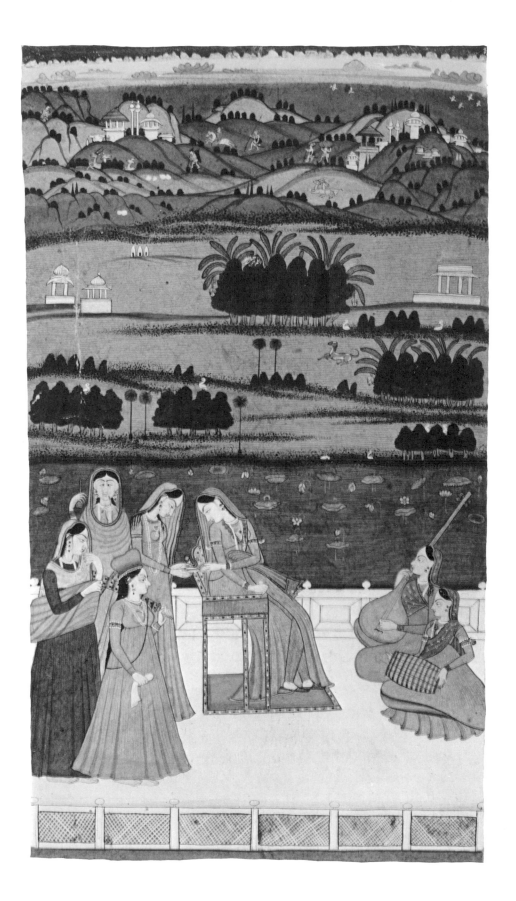

NURPUR, C. 1760
By Har Jaimal

74. *Radha and Krishna on a Terrace*

$9\frac{1}{2} \times 6\frac{1}{4}$ in.

Although this picture is by the same hand as 73 and contains similar ingredients—a terrace, chair, maids, musicians, lotus pond and landscape—the underlying situation could hardly be more different. Radha and Krishna are shown sitting side by side on a double chair in a state of idyllic happiness. Krishna has his arm round Radha's neck and a maid asserts his princely status by waving a peacock feather fan over his crowned head. The greatly enlarged lotus flowers stand high in the water, as if to proclaim the lovers' exaltation. Although the hills contain a few houses, there are no longer any people or wild animals and it is left to three cows to remind the viewer of Krishna's pastoral origins and Radha's humble cowgirl status.

Publ.: W. G. Archer, "Some Nurpur Paintings," *Marg* (1955), VIII, no. 3, 8–18, fig. 17; W. G. Archer, *Indian Miniatures* (1960), pl. 73; Archer, *Indian Paintings from the Punjab Hills* (1973), Nurpur no. 33; Archer, *Pahari Miniatures: A Concise History* (1975), col. pl. 29.

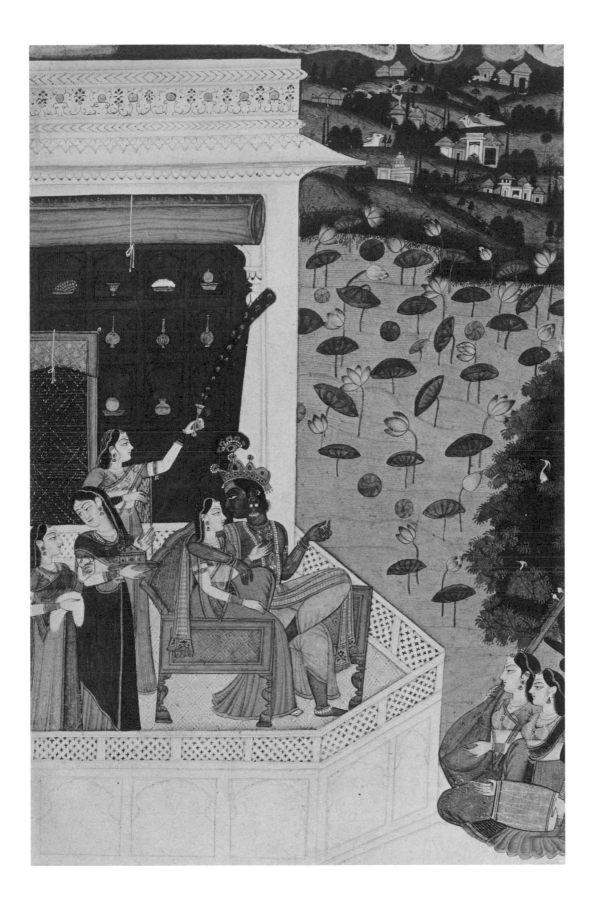

NURPUR, C. 1770–1780

75. *The Rejected Lady*

$8 \times 4^3/_4$ in.

Of the many amorous situations treated in Indian love poetry, that of "women in love," cheated, tricked, insulted or jilted by their lovers, was among the most poignant. In dream and fantasy, if not in real life, courtly ladies were expected to dare everything for romance and passion. It was assumed that they themselves must often take the initiative; trysts could not always be in the house and a couch of leaves in the forest must serve as bed. For forest trysts, a night of utter blackness was advised since, despite its obvious dangers, the lovers were unlikely to be detected.

Here a "woman in love," dressed in a skirt of impas-sioned red, a pale yellow bodice tightly framing her breasts, has reached the trysting place, prepared a couch of leaves and has waited in vain. She has dared a bright night with a full moon and the trysting place with its solitary tree invites exposure. The stalwart trunk, however, is emblematic of a steadfast lover, and it is only after hours of useless waiting that her patience has snapped. She has now thrown away the garland of white flowers which she intended for her lover's neck. She has begun to strip herself of ornaments. One tassel already lies on the ground and another is about to follow.

142

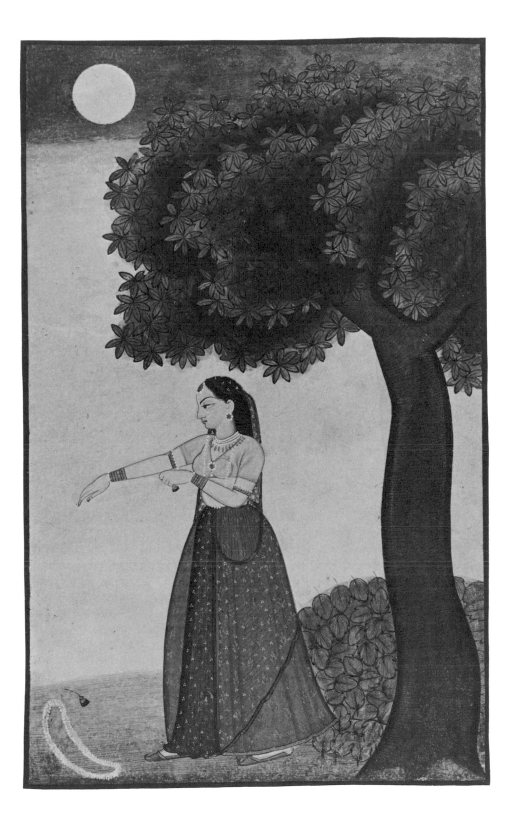

NURPUR, C. 1770–1780

76. *Raja Suraj Mal (1613–1618) of Nurpur Holding a Hawk*

$6\,^3/_4 \times 5\,^1/_4$ in.

This represents a posthumous celebration of Suraj Mal, elder brother and predecessor of the famous Jagat Singh (1618–1646). Although later Nurpur rajas collaborated with the Mughal emperors, Suraj Mal's defiance of Jahangir and his subsequent exile to Chamba, where he died, set an inspiring example. Veneration for his legendary bravery may explain why, in another version of this portrait, a large halo surrounds his head.[1]

The date of the present picture must approximate to that of 75 with which it shares a dazzling dark red (for background), a brilliant white (for turban) and a pale green (for the coverlet on the window sill). The dark blue of the lady's veil is repeated in its blue border. The falcon, with hooked beak, proudly perching beside its master, reinforces the subject's grim audacity.

1. Archer, *Indian Paintings from the Punjab Hills* (1973), Nurpur no. 37.

Publ.: Mildred Archer, W. G. Archer and Sherman E. Lee, *Indian Miniatures from the Collection of Mildred and W. G. Archer* (1963), pl. 45.

144

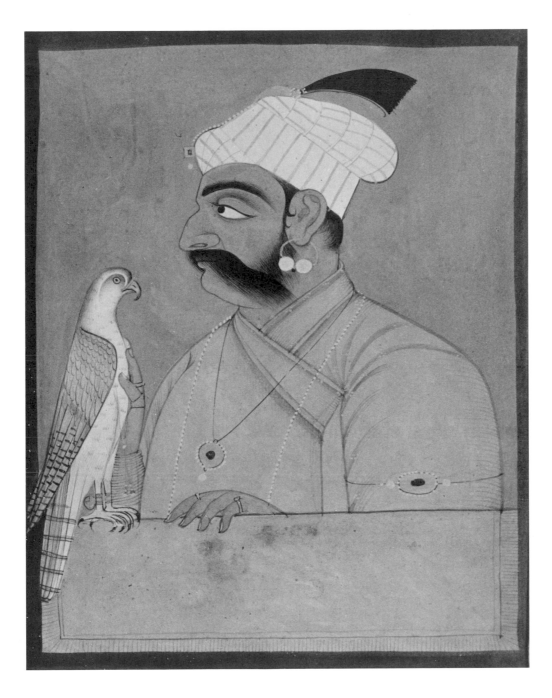

SIRMUR (NAHAN)

SIRMUR (NAHAN), C. 1830

77. *The Gathering Storm*

$8^{3}/_{4} \times 5^{1}/_{2}$ in.

Lying west of Garhwal, immediately to the north of the Punjab plains, Sirmur played a prominent role in the feudal struggles of the eighteenth century. It successfully withstood Garhwal, and its marriage alliances with Guler and Kahlur gave it important cultural links with states further to the west. Like Garhwal, however, it was ruined by the Gurkha invasion of 1803 and, until liberated by the British in 1815, it survived "in the dusk of a dimmed existence" (Tagore). From 1827 to 1850, it was ruled by Raja Fateh Parkash—"very gentleman-like and civilised," wrote Emily Eden in January, 1839, when visiting his capital of Nahan with her brother the Governor-General, Lord Auckland. Nine months earlier, she had noted in a letter:

We came up to Nahun yesterday morning by means of elephants and jonpauns. The Rajah of Nahun met us. He had his palace at the top, a sort of hill-fort, and a band of mountaineers, who played "God save the Queen" with great success. He is one of the best-looking people I have seen and is a Rajpoot chief, and rides and hunts and shoots and is active. Nahan is the nicest residence I have seen in India; and if the rajah fancied an English ranee, I know somebody who would be very happy to listen to his proposals. At the same time, they do say that the hot winds blow here and that his mountains are not quite high enough; and those points must be considered before I settle here.

Due possibly to the ravages caused by the Gurkhas, the earliest Sirmur paintings so far discovered date from 1820. By then relations with Garhwal had improved and their closeness is indicated by the wedding of Raja Sudarshan Shah (1815–1859) of Tehri Garhwal to a sister of Fateh Parkash. Under Sudarshan Shah's patronage, painting in Garhwal revived, and a further marriage by him to the two daughters of Sansar Chand of Kangra secured for him as wedding presents two of the greatest sets of Kangra pictures—a *Gita Govinda* of about 1780 and a *Bihari Sat Sai* of about 1785.[1] Under influences from these sources, Sirmur developed its own minor school of nineteenth-century Pahari painting.

Here, Radha and Krishna with three cowherd boys are sheltering under a tree as black storm clouds, edged with lightning, rumble above the Nahan palace. Verrier Elwin (*Folk-songs of Chhattisgarh*) has emphasized how common in Indian village poetry is the erotic image of cloud and storm—"the cloud that covers, the rain that falls, the storm that tosses to and fro"—and, in the picture, the storm has the same symbolic significance as in the following early English poem:

> O western wind when wilt thou blow
> That the small rain down can rain.
> Christ that my love were in my arms
> And I in my bed again.

1. Discussed and illustrated in Archer, *Indian Paintings from the Punjab Hills* (1973), Kangra nos. 33 and 39.

Publ.: Mildred Archer and W. G. Archer, *Romance and Poetry in Indian Painting* (1965), pl. 64; Archer, *Indian Paintings from the Punjab Hills* (1973), Sirmur (Nahan) no. 7.

146

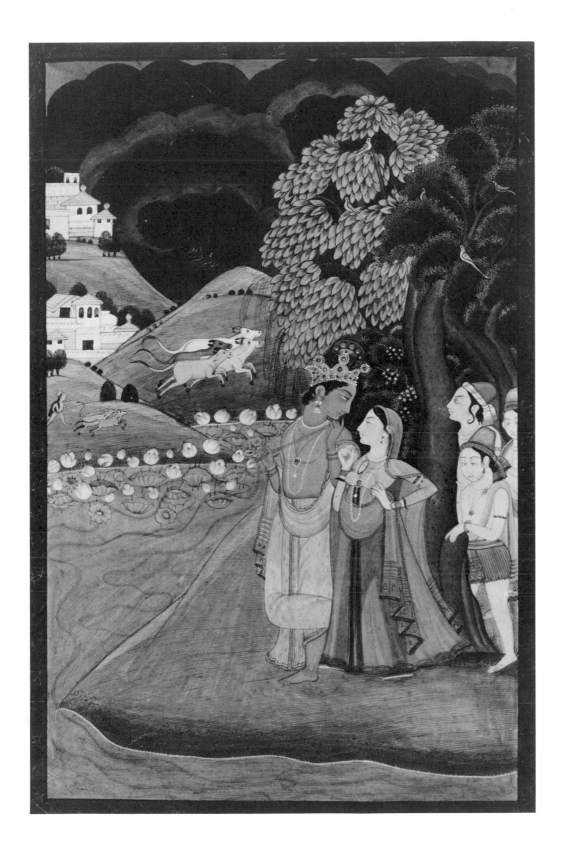

SIRMUR (NAHAN), C. 1830

78. *The Lonely Lady*

$8\,{}^{3}/_{4} \times 5\,{}^{1}/_{2}$ in.

Like 24 and 45, a study in frustration, the serenely calm face of the lady masking her inner agitation. A maid or confidante strives to make her "see reason" but as in Vidyapati's poem, she is overwhelmed with numb depression:

> The more I dwell
> On all my passionate thoughts

> Sadness unspeakable
> Drains my lonely love.[1]

1. W. G. Archer and D. Bhattacharya, *Love Songs of Vidyapati* (1965), 95.

Publ.: Mildred Archer and W. G. Archer, *Romance and Poetry in Indian Painting* (1965), pl. 66; Archer, *Indian Paintings from the Punjab Hills* (1973), Sirmur (Nahan) no. 9.

148

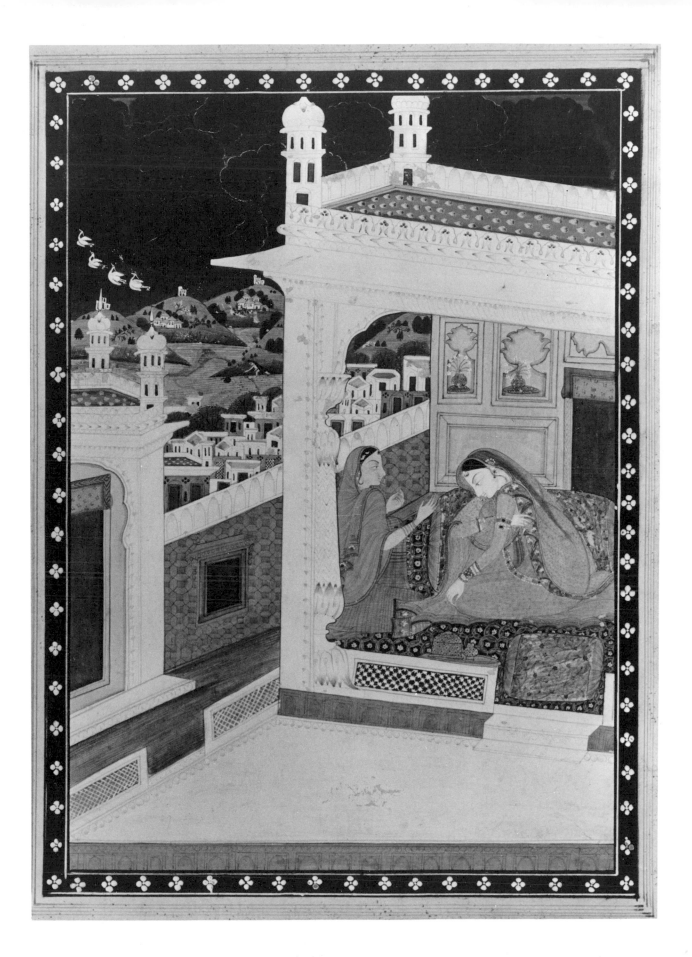

SIRMUR (NAHAN), C. 1830

79. *Radha and Krishna on a Bed of Leaves*

$9 \times 6^{1}/_{4}$ in.

As in the Kangra *Gita Govinda*, where the final stages of Radha and Krishna's love-making are depicted with unabashed candor, the two lovers are here shown naked save for a transparent red veil that barely disguises Radha's nudity. Krishna's discarded yellow cloth covers the bed of leaves and his long garland coils sinuously about them, as if defining a sacred piece of ground. It is significant that Radha is shown with a Shaiva tilak mark on her forehead, reminding one that even when welcoming Krishna to Mathura, the local women had first gone to worship the Devi. In many Pahari pictures, Krishna himself is also shown with Shaiva tilak marks—an indication of how involved in each other were the supposedly rival cults of Shiva and Vishnu. Once again, flowering trees, lotuses and storm clouds provide the lovers with a symbolic setting.

Publ.: Mildred Archer and W. G. Archer, *Romance and Poetry in Indian Painting* (1965), pl. 66; Mildred Archer, *Indian Miniatures and Folk Paintings* (1967), pl. 43.

150

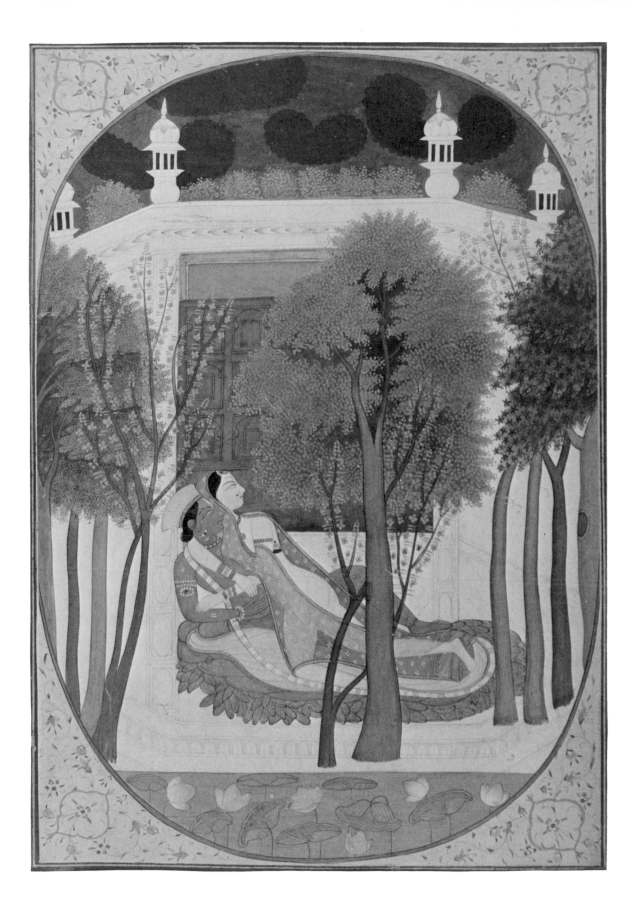

SIRMUR (NAHAN), C. 1830

80. *Radha and Krishna on a Bed at Night*

$9^3/_4 \times 7^1/_2$ in.

This picture is reminiscent of the Garhwal painting of Radha and Krishna on a bed (21), but with the difference that the time is night, not dawn, and oil-lamps glimmer in their phallic lamp shades. The lovers have still to finish their love-making but, instead of resting as in Botticelli's *Mars and Venus*, Krishna is actively toying with a strand of Radha's hair. Outside, lonely darkness drapes the palace.

Through its nearness to the Punjab Plains, Sirmur was one of the first Hill States to be exposed to Western influ-

ences. When the Russian traveler Prince Soltykoff visited it in 1842 and met Fateh Parkash, he noticed, among other things, "his French prints." "God knows where he got them from," he commented. Here their influence can be seen in the bunches of flowers elegantly inserted in the four spandrels.

Publ.: Mildred Archer, *Indian Miniatures and Folk Paintings* (1967), pl. 43; Archer, *Pahari Miniatures: A Concise History* (1973), col. pl. 40.

152

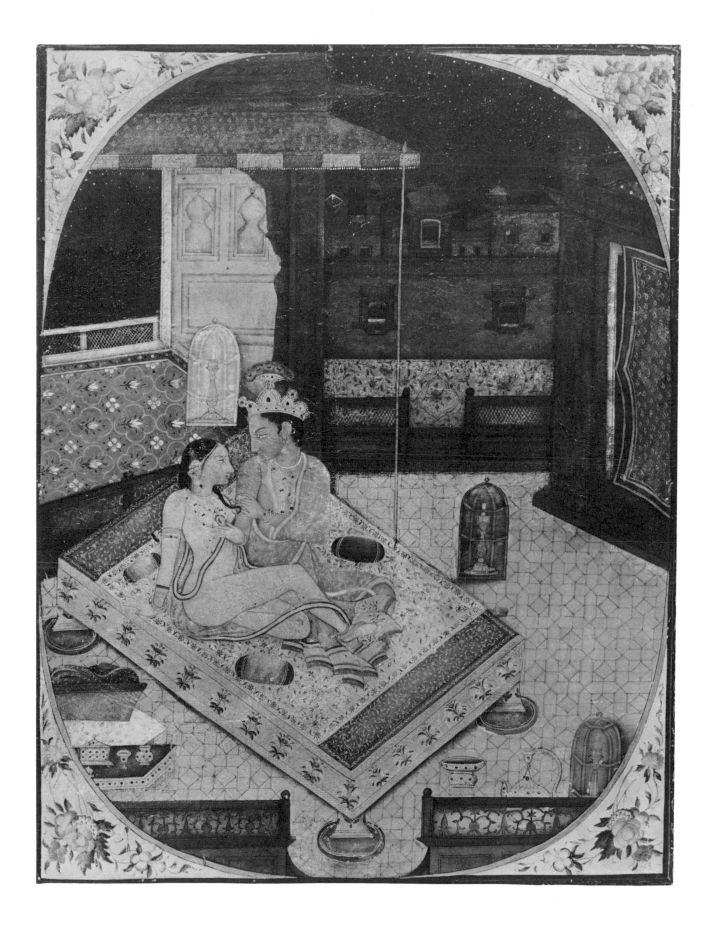

Bibliography

Archer, Mildred. "Indian Miniatures," *Art International* (1963), VII, no. 9, 20–23.

———. *Indian Miniatures and Folk Paintings* (London, (1967).

———. *Indian Paintings from Court, Town and Village* (London, 1970).

Archer, Mildred, and Archer, W. G. *Romance and Poetry in Indian Painting* (London, 1965).

Archer, Mildred, Archer, W. G., and Lee, S. E. *Indian Miniatures from the Collection of Mildred and W. G. Archer, London* (Washington, 1963).

Archer, W. G. *The Vertical Man* (London, 1947).

———. *Indian Painting in the Punjab Hills* (London, 1952).

———. *Kangra Painting* (London, 1952).

———. *Garhwal Painting* (London, 1954).

———. "Some Nurpur Paintings," *Marg* (1955), VIII, no. 3, 8–18.

———. *Indian Painting* (London, 1956).

———. *The Loves of Krishna* (London, 1957).

———. *India and Modern Art* (London, 1959).

———. *Indian Miniatures* (Greenwich, Conn., 1960).

———. Introduction to M. S. Randhawa, *Kangra Paintings of the Gita Govinda* (New Delhi, 1963).

———. "Reflections of an Art Historian," *Roopa Lekha* (1968), XXXVII, nos. 1 and 2, 78–87.

———. "A Tribute to M. S. Randhawa," *Roopa Lekha* (1969), XXXVIII, nos. 1 and 2, 47–63.

———. *Indian Paintings from the Punjab Hills* (Sotheby Parke Bernet, New York, London, 1973), 2 vols.

———. *The Hill of Flutes* (London, Pittsburgh, 1974).

———. "George P. Bickford: An Appreciation," *Indian Art from the George P. Bickford Collection*, ed. S. Czuma (Cleveland, 1975).

———. "The World of the Punjab Hills," *Apollo* (May, 1975), CI, no. 159.

———. *Pahari Miniatures: A Concise History* (Bombay, 1975).

Archer, W. G., and Bhattacharya, D. *Love Songs of Vidyapati* (London, 1963).

Archer, W. G., and Binney, E. *Rajput Miniatures from the Collection of Edwin Binney 3rd* (Portland, Ore., 1968).

Barrett, D., and Gray, B. *Painting of India* (London, 1963).

Binney, E. "Indian Paintings from the Punjab Hills," *The Connoisseur* (February, 1974), CLXXXVII, no. 744, 165.

Coomaraswamy, A. K. *Rajput Painting* (Oxford, 1916).

———. *Catalogue of the Indian Collections in the Museum of Fine Arts, Boston, Part V, Rajput Painting* (Boston, 1926).

Craven, R. C. *A Concise History of Indian Art* (London, New York, 1975).

Dalton, E. T. *A Descriptive Ethnology of Bengal* (Calcutta, 1872).

Dowson, J. *A Classical Dictionary of Hindu Mythology* (London, 1957).

Forster, E. M. *A Passage to India* (London, 1925).

French, J. C. *Himalayan Art* (Oxford, 1931).

Gangoly, O. C. "Dole Leela," *Rupam* (1921), II, no. 6.

———. *Ragas and Raginis* (Calcutta, 1934).

Ghose, Ajit. "The Basohli School of Rajput Painting," *Rupam* (1929), no. 37, fig. 7.

Goswamy, B. N. "The Problem of the Artist 'Nainsukh of Jasrota'," *Artibus Asiae* (1966), XXVII, 205–210.

Gray, B. "Painting," *The Art of India and Pakistan*, ed. L. Ashton (London, 1950).

Hollings, W. *The Prem Sagur* (Lucknow, 1880).

Khandalavala, K. "Balvant Singh of Jammu: A Patron of Pahari Painting," *Bulletin of the Prince of Wales Museum* (1951–1952, published 1953), no. 2, 71–81.

———. *Pahari Miniature Painting* (Bombay, 1958).

———. "Notes on Pahari Painting," *Lalit Kala* (1975), no. 16, 37–40.

Lawrence, G. *Indian Art: Paintings of the Himalayan States* (London, 1963).

Lee, S. E. *Rajput Painting* (New York, 1960).

Mehta, N. C. *Studies in Indian Painting* (Bombay, 1926).

Mehta, N. C., and Chandra, M. *The Golden Flute* (New Delhi, 1962).

Ohri, V. C. "An Agreement Signed by Balwant Singh," *Lalit Kala* (1969), no. 14, 38–40.

Randhawa, M. S. *Kangra Valley Painting* (New Delhi, 1954).

———. "Kangra Artists," *Roopa Lekha* (1956), XXVIII, no. 1, 4–10.

———. *Basohli Painting* (New Delhi, 1959).

———. *Kangra Paintings of the Bhagavata Purana* (New Delhi, 1960).

———. *Kangra Paintings on Love* (New Delhi, 1962).

———. *Kangra Paintings of the Gita Govinda* (New Delhi, 1962).

———. *Kangra Paintings of the Bihari Sat Sai* (New Delhi, 1966).

———. *Kangra Ragamala Paintings* (New Delhi, 1971).

———. "Studies of Pahari Painting," *Roopa Lekha* (1974), XLII, nos. 1 and 2, 80–85.

———. *Travels in the Western Himalayas* (New Delhi, 1974).

Randhawa, M. S., and Bhambri, S. D. "Basohli Paintings of Banudatta's *Rasamanjari*," *Roopa Lekha* (1967), XXXVI, nos. 1 and 2, 17.

Randhawa, M. S., and Galbraith, J. K. *Indian Painting: The Scene, Themes and Legends* (Boston, London, 1868).

Rawson, P. *Indian Painting* (London, Paris, 1962).

Shastri, H. P. *The Ramayana of Valmiki* (London, 1957), II.

Skelton, R. *Indian Miniatures from the 15th to the 19th Centuries* (Venice, 1961).

Sutton, D. "Art from the Punjab Hills," *Financial Times*, 19 February 1974.

Waldschmidt, E., and Waldschmidt, R. L. *Miniatures of Musical Inspiration in the Collection of the Berlin Museum of Indian Art: Ragamala Pictures from the Western Himalaya Promontory* (Wiesbaden [English edition], 1967).

Welch, S. C. *A Flower from Every Meadow* (New York, 1973).

———. "Indian Miniatures from the Himalayan Foothills," *Apollo* (May, 1974), CXLVII, 378–379.

Welch, S. C., and Beach, M. C. *Gods, Thrones and Peacocks* (New York, 1965).